HOW TO MAKE
A LIVING
AS A PAINTER

HOW TO MAKE A LIVING AS A PAINTER

BY KENNETH HARRIS

WATSON-GUPTILL PUBLICATIONS New York

First published 1954 in New York by Watson-Guptill Publications,
a division of Billboard Publications, Inc.,
1515 Broadway, New York, N.Y. 10036

ISBN 0-8230-2400-8
Library of Congress Card Catalog Number: 64-24248

Manufactured in U.S.A.

First Edition
 First Printing, 1954
 Second Printing, 1958
Second Edition
 First Printing, 1964
 Second Printing, 1967
 Third Printing, 1970
 Fourth Printing, 1973
 Fifth Printing, 1977
 Sixth Printing, 1978

Contents

For Irene, who made it possible,
and for Kathryn and Albert, who made it necessary

Foreword

"How is it that you make a living by painting when so many painters with more ability do not?" That question has kept coming up for several years in my own mind; and, phrased more charitably, has been asked me by many others.

This book is an attempt to answer that question. When I began to write it, I had never tried to analyze my methods or my beliefs. The things I had done came about through force of necessity and habit of mind. As the book progressed, it surprised me to find that the ideas did seem to make a kind of pattern. I hope it will prove to be a pattern which lends itself to successful adaptation.

This is not a book about how to paint. It is a book about how a person who paints as he pleases can make a living from his work. No revolutionary ideas are expressed. The things I am suggesting are things anyone can do. If he is a competent painter he can make a living by doing them.

I am indebted to more people for help of various kinds than I can name here. Special thanks are due to these: Mr. Warner Twyford of the *Norfolk Virginian-Pilot* for suggesting the idea of the book, and for his advice and encouragement; Mr. Lincoln Rothschild, formerly director of Artists Equity Association, for his advice and for permission to use material developed by Artists Equity; Miss Helen Scott, Mrs. Christine Camp, and Mrs. Fenetta Waples of the Norfolk Public Library research staff for finding the answers to many questions; and to *Fortune Magazine* for permission to use material from that publication. The points of view expressed in this book are, however, specifically my own and should not be considered as representing the ideas of those who have so generously helped me.

Finally, a mention should be made of the girl who typed so

indefatigably, and who praised, criticised, exhorted, cajoled, cooked my meals, emptied my ash trays, corrected my grammar, and kept the children quiet. That was my wife.

July 2, 1954

Foreword to Revised Edition

TODAY'S MARKET for paintings is the market which the first edition of this book described and forecast. Events of the past ten years have made the ideas it advanced as to reaching that market increasingly useful. Today there are more people who can buy paintings; they have more money; they are more receptive to paintings—and as a result, more artists are making a living. What were hopeful theories in 1954 are now methods tested with considerable success by some thousands of painters.

A surprising number of them have written to me. The most satisfying result of the original edition has been the hundreds of letters I have received from all over the country. Letters have come from young people, old people, art students and professional painters, housewives, teachers, ministers (one fellow preached a sermon on the book), brokers, cab-drivers—all kinds of people—and almost all said the book helped them.

Writing a book, particularly a book which presumes to tell other people what to do, is a responsibility I had not originally considered as serious as I now think it is. An awful lot of people have bought this book, and I hope it helped the ones I didn't hear from as much as it helped the ones who wrote.

I have learned some things in the last ten years; I have rewritten the book to incorporate these things; and I have added three chapters of new material. The statistics, which have more than justified the optimistic forecasts of 1954, were brought up to date by Professor Jack Reed of Old Dominion College, a kind man with a gift for enthusiasm, to whom I am deeply indebted.

If you find my suggestions helpful, maybe you will write to me, and I shall appreciate that. I don't know when I can answer, but I am keeping score, and so far our side is way ahead.

KENNETH HARRIS

Norfolk, Virginia
August 25, 1964

HOW TO MAKE
A LIVING
AS A PAINTER

I · The Painter's Problem

A PAINTER, like everyone else who does useful work, should expect to make a living from that work. Potato farmers, piccolo players and pathologists follow their vocations because they like the soil, or music, or studying tissues — but all of them anticipate also that their efforts will bring them enough money to live on. Painters are just about the only people who have given up the idea. And yet they need not have.

It is true that very few artists make a living from the sale of their work. This has become so generally the case that most of them accept the idea that it can't be done. Further than that, many have come to feel that an artist should not expect to live by his work, and that one who does must first "betray his talent."

This is a new notion — an illogical and destructive one. The creation of paintings is the creation of nourishment for man's spirit, a useful — a necessary — work. A competent painter should expect to live from that work. In the past, painters have expected to support themselves, and have generally succeeded. Some have failed, for one reason or another, just as some people in other endeavors have failed. Few have grown wealthy, but most have lived from their work.

The starving artist in the garret became a sentimentally roman-

tic figure about the turn of the century. Because some painters had a hard time, and later turned out to have been geniuses, the notion spread that all good painters starve, and that a painter who is well-fed and properly clothed is therefore suspect. This is, of course, foolishness.

Start with the expectation of success. Do not become one of those sad, egotistic souls who welcome indifference and neglect as a sure sign of genius. It is true that the life of a painter is its own reward, and that the artist follows his vocation because he must, without any primary interest in money-making. But it is also true that a certain amount of money is necessary if he is to continue. And it is quite possible for him to make enough money to live on by painting, without compromising his principles.

Any competent painter who works hard and is reasonably prolific can, from the sale of his pictures, have an income comparable to the incomes of those in other professional fields. Also, he can devote all his time to painting.

With the best of our painters finding it necessary to take teaching jobs — with nationally known artists selling less than $2,000 yearly — that statement may seem fantastic. It is nevertheless true; it has been proved by my own experience. No "showmanship" is required, and no high-pressure salesmanship. Only one thing is necessary — a reorientation of the artist's ideas as to the market for painting.

Let's look at the problem. The artist's job is to create in line and color a communication to his fellows concerning his reactions to the world. To do this best, he needs to be free from excessive economic pressures. Unless he has a private income, this means, in its simplest terms, that once a painting is completed it must be sold so the artist can paint another one. If the painter is honest, this concern about a sale does not arise until the painting is finished; then it becomes paramount.

Artists have always needed patrons; that is to say, customers. At one time it was the church and the wealthy families of feudal times who kept them going. At another period the patronage of the king, or of the nobility, decided what painters were to be successful. With the rise of capitalism, the man who had made his millions in railroads, or steel, or copper became — once his

dynasty was established — art's patron.

This is the day of big corporations and big government, and, true to form, artists have looked hopefully toward this big money for patronage. There is the feeling that perhaps corporations should support the art of painting, or that the government should subsidize artists, as it has subsidized butter and airlines. To an extent big business has bought paintings, and for awhile, under WPA, the government did subsidize art. And as always when art has found patrons, it began to flourish, new talent sprang up, and painting was revitalized. It has often been pointed out that many of today's best painters developed under the protective wings of the WPA projects.

But it has not been enough. The patronage of the corporations often placed strictures on the artist's freedom to develop his own ideas, and the patronage of government inevitably made artists the butt of politicians.

Faced with this situation, artists, who are notoriously bad business men, have more and more put themselves in the hands of galleries, and have turned over the task of finding customers to these agents. It has not worked very well — practically speaking, no artist makes a living by his brush today.

Are the agents at fault? Only to the extent that they have not done the one first thing that every sales manager should do: that is, thoroughly analyze the market for his product. Artists' agents, and artists themselves, have taken for granted that the market for contemporary American paintings consists of museums, large private collectors of art, and other persons of considerable wealth, most of whom live in or visit New York.

That is why almost every painter aims at a one-man show on Fifty-seventh Street as the first milestone of success. The sad fact is that even when this aim is achieved, it is evident that not many one-man exhibits sell enough to pay expenses. The artist ends with a sense of empty elation, a slim handful of noncommittal reviews (the art critics take pride in not shooting at a fledgling) and a bill from the gallery to cover advertising and rental.

Another thing the artist wants is representation in the big juried exhibits. He feels that he needs the recognition these bring. But you will find, as I have, that packing, shipping and insurance cost

money, and even when your painting is accepted, the card that notifies you of acceptance and the news clippings about the show are equally inedible. And who sells pictures out of these exhibits? Artists Equity, the one constructive force that is devoted to finding a solution to painters' problems, has studied this and their conclusion is that "Few sales are made. Except for rare instances, the institution makes no effort in this direction."

The fact is that representation in even the largest national exhibits, plus an occasional sale to a museum, plus an agent on Fifty-seventh Street, does not constitute a method by which a painter can make a living. That is being proved every day. I have sold some paintings to museums, and one of the larger and more successful New York galleries handled my paintings for years, but I would be unable to live for two months on what they sent me in a year.

Since these methods have proved inadequate, most painters have decided that the situation is hopeless, and have retreated to teaching or some other work.

And yet the situation is not hopeless. It is even promising. The real difficulty is that, using the present methods, artists are not reaching and can never reach the great market that potentially exists for contemporary American painting. Although present methods cannot work, there is a method that does. This book describes that method.

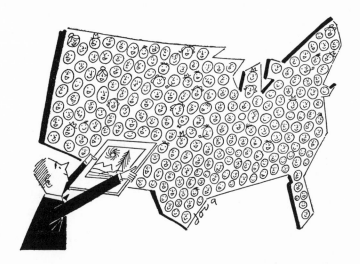

II · The Opportunity for Painters Today

LAST SPRING a young painter came to see me. He had just graduated from college with a degree in Fine Arts. He had exhibited paintings in some fairly stiff juried shows while he was still in school. One of these paintings had attracted favorable critical comment. When he visited me, he brought a portfolio of watercolors and several oils, all of which indicated a promising talent in process of thoughtful development.

After we discussed his paintings, I asked him what he planned to do next. "Well," he said, "I may go back to school another year and get a Master's degree, so I can teach. I hate to go out and get a job and give up painting altogether."

I asked him why he didn't just start out to be a painter. He seemed surprised. "I'd starve to death," he said. "There's no chance for a painter in this part of the country."

Here was a twenty-two year old man who had been interested in painting all his life; who had spent four years studying to develop that interest into ability; who had already produced creditable work which showed promising originality — a man with the world before him, with no ties, no obligations, no handicaps. It seemed to me that he was one of the earth's fortunate people: talent, training, opportunity, freedom, all were his. And he was

giving it all up, because he was sure that a painter could not possibly make a living by painting.

And yet he could have. All he needed was the realization that a painter can be an integral part of the life of those around him; that the art of painting is not a thing apart—not necessarily a narrow cult practiced "by the few and for the few"; but a broad all-enveloping art-form of value to everyone. And that the market for painting is almost as broad as the need for it.

If this sounds idealistic and impractical when expressed in abstract terms, it becomes entirely practical when translated into action. The market for paintings of honest merit encompasses literally millions of people, if these paintings are for sale at a price within their reach. To over-simplify just a little, the problem of the American painter, and his opportunity, lie in this fact: There are very few people who can pay $1,000 for a painting, no matter how much they want it, but there are millions who will pay $50 to $250 for a painting which appeals to them.

Let's study this market.* There are fifty-eight million family units in the United States—a family unit being defined as (1) families of related persons living together and (2) individuals residing alone or with others. In 1953, when the first edition of this book was written, there were fifty-two million family units in this country. By 1980, there will be eighty million. In 1953, only twenty-three million family units had incomes above $4000, which economists said gave them an opportunity for luxury spending. Today, the median income of *all* family units is about $5000— that is to say that half of all families, or twenty-nine million of them, now have incomes of $5000 or over, and may therefore be considered as having money to spend for paintings, if they want them.

What *Fortune* Magazine called attention to as the "Wonderful Ordinary Luxury Market" in 1953 has grown steadily since then. The number of people in this market is larger each year; the

* The statistics for the year 1953 which follow are from "The Wonderful Ordinary Luxury Market," published by *Fortune* Magazine, December 1953, copyright 1953 by Time Inc., and used by permission of *Fortune*. The statistics for the 1960's which follow are from material furnished by Mr. T. J. Reed, Director of Business Research, Old Dominion College, Norfolk, Virginia.

amount of money they have available for luxury spending is larger; and the present indication is that both will continue to increase.

This is a situation that never has occurred before in all the world. It is a market for paintings which is larger, wealthier in total available money, and more varied than any market painters have had since the first artist scratched a drawing of a buffalo on a piece of bone and leaned back and smiled.

A generation ago, and all the generations before that, all luxury spending was in the hands of a few very wealthy people. Throughout history, artists sold paintings to that small market; galleries catered to it. When things changed—when that market narrowed and was replaced, as it has been, by the gigantic new one that now exists—neither the artist nor the gallery became aware of the fundamental and revolutionary nature of that change.

Today, an overwhelming percentage of all luxury spending is done by people with incomes of less than $25,000 per year. And about half of that is done by people who make less than $10,000 per year. In 1954, these two groups had 13 billion dollars to spend on things that appealed to them, and the trend continues toward more and more money available for luxury spending on the part of these groups. Today, the median income of urban family units is about half again what it was in the early 1950's.

Let's say that today people with incomes above $5000 after taxes can afford paintings. This group earns 186 billion dollars per year: 78% of the income of all urban families. This is the real market for contemporary American paintings. It is not the market of a half-century ago, when forty thousand very wealthy people accounted for one third of all luxury spending. That was the day of big yachts, big country estates, luxurious town houses, fabulous art purchases. Today that market has largely disappeared. Where ten palatial yachts were tied up, there are now a thousand twenty and thirty foot cruisers. Where country estates sprawled, there are suburban developments with hundreds of twenty and thirty thousand dollar homes. The town houses are gone and so are the fabulous art purchases. A few years ago, it was estimated that only seven thousand people in this country still have incomes above $100,000 per year, and the money they have for luxury spending is less than 4% of such money.

There are additional factors which indicate that the new, broad market which has been developing contains more and more people who are ready to buy paintings. Three out of four families now live in urban areas, and that trend toward urban living continues. The educational level and the cultural opportunities of the urban population are higher and continue to increase. There are today nine million college graduates, more than two and one half times as many as in 1940. The upward shift in income, together with increased leisure and the richer cultural climate of city life, have been accompanied by a great deal of "trading up" in tastes. More and more families are participating in cultural enjoyments which, only a few years ago, were beyond their cultural horizon and their economic reach.

It amounts to this: Half of the family units in the United States, twenty-nine million of them, make more than $5000 per year and have money to spend for jewelry, or travel, or perfume, or furs— or paintings. There are not many who can, or will spend $1000 for a painting, but every one of them can afford to buy a painting for $40 or $100 or $200 if he wants it.

Most of these people have never bought a painting. They have never been considered by artists, or artists' agents, as prospective purchasers. They do not think of themselves as art purchasers. By and large they do not go to art galleries—nor are they conscious of their need for painting.

And yet more and more of them are culturally ambitious. They are the people who are today spending millions on recordings of good music. They are the people wooed so successfully by the book clubs. They are the people who support lecture courses and community concert series. They are the people who read the magazines on home decoration. In their living room they walk on a two hundred dollar rug, sit on a four hundred dollar sofa, watch a five hundred dollar television set. And on their wall is a seven dollar picture.

It can be said—it is said—that most of these people are artistically illiterate, that their taste is bad, that they will neither try to understand nor support the efforts of the serious creative artist. Nobody knows, for sure, because artists have priced themselves out of this market.

But say that it is true. Here is potentially the broadest market for paintings in the world's history, made up of people who, whether they know it or not, need what artists can bring them and are able to pay for it. Should the painter turn his back on them because they are not already at the cultural level he could wish? Does a first grade teacher look at her timid but willing pupils and say, "My God, send them home! They can't even read!"? No, she gives them each a book and, a few years later, some of them, at least, are reading Dante and Shakespeare and Tolstoi — and James Joyce and T. S. Eliot.

Or approach it from another angle. Suppose that every one of the twenty-three million families that could afford it had one original work of art on its walls. If you believe in art as a living force that works for good, then think of the tremendous impact of those paintings on American life. And if you believe in the artist as the interpreter of life to his fellows, think of the surge of new creative effort, if that effort were being accepted as an integral part of American life.

What are the objections? Would these people buy a lot of bad work? Probably they would, for awhile, just as did the millionaires who were patrons of the arts in the last generation. But can anyone doubt that as painting broadened its audience, and as its new patrons developed taste and discrimination, that the good would more and more be recognized and survive, and that the bad and the mediocre would more and more be recognized and discarded?

This power of discrimination comes with experience. It is not a divine insight given to a few. Art's arbiters of taste have been wrong quite often. In the long view, the merit of any art is decided by a slow and inevitable process of selection — that which lives, does so because it is what man has come to love and wants to keep. As Rilke says, "Works of art are — with nothing to be so little reached as with criticism. Only love can grasp and hold and fairly judge them.

I believe that, and I hope you do. It offers a great opportunity for usefulness. It can take art out of its present narrow room and make it a living part of American life; and, because of that very fact, can give economic security to thousands of painters, without compromising their artistic integrity. The broader the audience,

the more opportunity there will be for freedom.

How does the painter approach this opportunity? By painting what he believes in, *and by selling his work at a price that will enable him to sell all he produces, whatever that price is.* Persons who have never bought paintings will begin to buy them at *some* price level. As the artist's ability increases, and as his work gains recognition, that price will increase. The fact that he is selling his work steadily, and thus has an income, makes his progress possible. In the beginning, his income will be low, but there is a difference between having a painting hanging in an art gallery for two years, or four, priced at $1000, and in selling that painting for $100 and thus being able to paint another one.

Artists to whom I have talked of this idea have had two major objections. The first one is that their work is worth more than the kind of prices I talk about, that they would be giving their paintings away. The answer to this is obvious. The money received for a work of art has never had any necessary relationship to its artistic merit. The immortal greatness of Brahms 1st Symphony is not affected because a recording of it by one of the world's great orchestras can be bought for less than $5; nor does a Bouguereau painting become less meretricious because it was once sold for $10,000. The artistic value of a work of art for anyone depends upon the emotional release that he gets from it. Its price depends on what he is willing and able to pay for it. Whether the artist sells it for that depends on how badly he needs the money.

As long as the distinction between artistic merit and price is kept clearly in mind, there can be no problem about what your paintings are worth. In terms of money they are worth what you can sell them for; artistically they are worth whatever emotional content they communicate to others.

The second objection is that this method of selling will not bring in enough to live on. Well, the present method is not bringing in enough to live on. In the beginning of your career on this new basis you will have a limited income, and you'll have to live cheap—but you can paint all day long, every day. That's what you want, isn't it? Under present selling methods, the situation will never improve, but will get worse. Using the method I am advocating your situation is apt to improve with your ability, and

you will be working every day to develop that ability.

As for the necessity of living on a small income, G. K. Chesterton has the answer. "An inconvenience," says he, "is only an adventure wrongly considered." When I began as a painter, I went from a job that was paying me a pretty good income. I had been living in a nice apartment, had been driving a new car, had been travelling extensively, using an airline credit card and staying in the best hotels. I am afraid I was a typical advertising man.

In Galveston, where I started out to be a painter, I lived in a one-room shack on the beach, and later, when my money got lower, lived in a boatyard. I rode a second-hand bicycle which cost $15. It was given to me by Buck Schiwetz, the artist who had encouraged me to take the plunge. I did my own cooking over an oil stove. But I was also painting every day and I was very happy.

During the twenty-two years since then, I have sold the pictures I painted at prices which have enabled me to sell all the work I've done. In the beginning, these prices were very low. As my work improved, and became more in demand, I raised prices, but only as much as the situation justified. In doing this I have simply followed the law of supply and demand, which has historically governed the price of every item in our economy *except paintings*.

And although it has never been an easy life, it has not been hard, although it may have been harder for me than it would be for you if you have more than ordinary ability, which I have not. My experience in five cities, from Colorado to Virginia, has shown me that it is possible for a painter who works hard, and produces competently, to make a living for himself and his family—because everywhere in this country are people who are ready to buy paintings when the prices are within their reach.

The market is here, all around us, and it is the only market for American paintings. There is no other. Twenty-nine million American families, each with a little money to spend on things that will enrich their lives. They are already in process of cultural awakening, but they have been overlooked by galleries, which are still gazing fondly after the vanishing millionaire. They have been ignored by artists, and ridiculed by critics. They have been made to feel their ignorance of painting, and they are shy and resentful.

But they can be interested in painting. It can become part of their lives — a valuable part — if they are given the opportunity to participate in the search for the good and the lasting values of art. This can be done by placing the work of artists before them and within their reach. By doing this, painters can make a contribution to the life of the people around them, and precisely because they make this contribution, will then be able to make a living by painting.

talk, talk, talk

III · *The Artist's Job*

THE PAINTING of pictures is a lifelong process of learning, in which each painting is an element. It may be a good painting, or mediocre, or bad; but once it is completed the painter has learned all he can from it. After a painting has served this purpose for the artist, he displays it in public, hoping that someone will find in it the emotional content he attempted to put there, and will pay him a sum of money in order to possess it permanently. That is a complete statement of the artist's job, of his usefulness to society, and of his method of earning a living.

Not every artist, it will probably be said, can take part in painting for the audience described in the preceding chapter, although I do not see why not. But let's explore the point. What kind of a painter can do so?

This book has made no mention of schools of painting, and will make none. The kind of painting a man does is a matter he must decide alone, just as its validity, sooner or later, must be decided by his fellow men. But however he paints, there are certain things he needs in order to succeed. Certain things, I mean, besides that sensitivity to the world around him which made him want to be a painter.

The first thing any painter must have is a capacity for hard

work and unremitting effort. It is not a coincidence that so many great artists have been tireless workers. If you have seen lists of the works of Rembrandt, or read the thick notebooks of Leonardo, or a catalog of the incredible amount of work done by Van Gogh in the ten short years he painted, you have been amazed, as I have, at the gigantic capacity for work that these men had. And there are countless others who worked as hard and produced as prodigiously.

Hard work will not make you a painter, but it is pretty certain that you will never be a good painter, or a successful one, unless you keep at it like a beaver getting ready for winter. A serious painter, I think, never has to sit around waiting for "inspiration." He has so many ideas, so many questions, so many projected paintings in his mind that he can never find the time for all he wants to do.

Even if your work sometimes seems at a dead end — and it will — go to work as regularly and work as steadily as does a man who has any other serious and demanding job. There is no depression that cannot be cured by doing a good piece of work.

In my own experience, I have found that my work is better, on the whole, and develops faster, when I am steadily at work every day. And I have found that my mood has little to do with this. I have often gone out to work when I was discouraged and upset, and come home with a painting far above my usual level — just as I have sometimes gone out feeling that I could lick the world and come home with a real stinker.

Second, and just as important as the will to work, a painter needs an alert power for self-criticism. He needs to be able to look at his work more sharply than do his critics. I remember a one-man show that came to a town where I once lived. The local reviewer of art shows was, it seemed to me, rather severely critical of what I thought was a good exhibit. I said so to the painter when we met. "Oh," he said, "that wasn't so bad. He liked a lot of them. There were only two in the show that are anywhere near what I was after."

This man believed in the work he was doing. And the work in that show was the best he could do. A painter must believe in his work. But it is one thing to believe you are on the right road, and

another to think you have already arrived at your destination. The difference is vital to your progress as a painter. It is not a comfortable thing to be eternally dissatisfied with what you have done, but it insures growth.

The third thing a painter must have is a willingness to live simply. It is possible that you can make a living as a painter, but it is not likely that you will ever be wealthy, or even prosperous in the usual sense of the word. If you want an expensive automobile and a home in a fashionable neighborhood, you had better not try to be an artist. After all, being a painter is a great privilege, and unless you are willing to forego most of the chromium plating that adorns modern living for the satisfactions and excitements of painting itself, you are in the wrong field. J. M. W. Turner, says a biographer, "rose early, worked hard all day, wasted no time over his simple meals, and his homely way of living made him easily contented with such rude accommodations as he chanced to find."

The fourth thing a painter needs is independence of spirit. Stay alone. More young artists have been smothered in the comfortable nest of an art colony than in any other way. It is a lovely theory that artists can group together and, because of their common interests, can find not only pleasure but inspiration. I do not believe it. There is the danger of influence, and a painter's work, first of all, must be his own. And there are the hordes of dilettantes, who talk and talk and talk, and try to disguise with esoteric language the inadequacies of their occasional painting. If, instead of talking, every person in an art colony went off by himself and painted, little would be lost except the self-assurance that curses these groups, and each person would learn more about his task than he is apt to get from a year of fine-spun theorizing.

Artists say that they like living in a sympathetic atmosphere, but what they really like is the sense of importance, the sense of security that comes from being part of such an insulated group, where the members feed one another's ego, safe from a crude world that does not understand.

But this is fatal, precisely because the group is insulated from the world which, after all, is the only world we've got, and a fairly magnificent and remarkable sphere. These people have cut them-

selves away from their source, and from their audience as well. To paint meaningfully about the world a painter must experience the world. He must experience it alone, and his answers to its sharp questions must be his own.

The four things are all you need. The will to work, the power of self-criticism, willingness to live simply, and the courage to look at the world as it is, and find its meanings. Keep alone and keep at work. Keep alone, because alone you can follow your own ideas wherever they lead. Whatever they are, they are what you have to contribute to painting. And keep at work, because you will never have enough time to explore the infinite possibilities of painting—and because only by constant work can you make your painting live, and grow.

IV · Money—and Freedom

ONE DAY, walking along a street, I happened to see fragments of an old brick wall projecting from a patch of weeds in a vacant lot. The interplay of color and texture in the crumbling brick—dull orange and soft red, purple-blue and olive-gray, crisp fractured edges and powdery decay, all interlaced with the acid greens of the rank weeds—knocked me flat. I came back the next day and made a painstaking study of it.

When I had almost completed the painting, a passer-by asked, "How in the world did you happen to pick that out to paint?" I tried to explain what made me do it. "All right," he said, "but who's going to buy such a picture?" I hadn't thought about it, and I suppose I said something like "Well, you never know."

As it turned out, about a month after that the painting was selected from an exhibit by an architect, and it now hangs in his office. He has told me why he likes it, and I'm glad to say he finds in it the things I tried to put there.

Paint what you believe in. Put into your pictures your personal feelings about the world. Your paintings may be realistic or abstract, they may satirize customs or embody social protest; they may be simple and peaceful as dawn, or complex as a great machine—so long as they are imbued with love for life and

27

search for truth, there will be, for someone to find there, the "shock of recognition" that will make him want the painting.

There are two conditions: Your paintings must be exhibited where a great many people will see them, and they must be priced so that almost anyone can buy the one he wants.

This is no new thing. Artists have never let their patrons decide how they should paint, but they have always sold their work for prices that their patrons were able and willing to pay. When Gainsborough was thirty-two, and had been painting portraits for twelve years, his price for a half-length portrait was five guineas, for a full-length portrait, eight guineas. As his fame spread, and his work began to be in greater demand, he raised these prices, but only then.

And in Holland in the 1600's, it was customary for companies of militia to subscribe a fund and buy a painting of the company to be hung in their assembly hall. The company of Francis Banning Cocq was one of many such organizations which raised this kind of a fund. They hired Rembrandt van Rijn, one of the painters of the town, to do the job. Rembrandt painted for them the picture we call "The Night Watch." He did not allow them to influence how he painted—the fact that his painting was unsatisfactory to most of them did not move him. He believed in it. But 1600 florins (about $650 today) was the going price for such a painting, and he did the work for that amount.

J. M. W. Turner began his art career by selling drawings which he displayed in his father's shop window. He priced them at two and three shillings each. In the evenings, he made drawings for a Dr. Munro "for half a crown and his supper." When, in later years, someone sympathized with him for having been forced to begin in such a manner, he said, "Well, and what could have been better practice?"

The examples could be multiplied. Artists have always accepted the idea of basing their prices on the market for their work, just as has every other person with something to sell. They must do so today—a fact which has nothing to do with their freedom to paint as they please.

For some reason, and I think the blame can be laid at the door of the art galleries, the success of a painter and the aesthetic value

of his work has become confused with the amount of money he gets for a single painting. Perhaps in a society where success and prestige in almost every field are measured by profit, this is inevitable. But it is false.

Too many times, even in those art magazines which decry public taste, I have read about "Mr. Blurp, whose painting 'Composition #27' has been purchased for $5,000," as if that fact had any relation to the merit of the painting. People have been led to believe that the "Blue Boy" is a great painting *because* it cost a fortune. And by a sort of reverse logic, painters price their work at figures which are, in today's market, fantastic — and then beat their breasts because they are neglected.

All this talk about an artist "keeping his freedom" and "refusing to compromise with the economic pressures that are beating him down" grows tiresome. Nobody is being beaten down, and there is room for all the individuality and freedom any artist could want. But when a man exhibits his work — especially when it is new, experimental work — and puts prices of $300 and $500 and $1000 on small canvases, and does not sell them, he is not being beaten down. He is just being completely unrealistic. The people who would buy his paintings do not have that kind of money. The only market that exists for American paintings, whether they be abstract, expressionist, romantic or whatnot, is made up of people who cannot pay such prices. Cannot!

I have talked to painters, and to art critics, who are convinced that the art of painting, or, as they always put it, "significant painting," can never include the general public as patrons — that it can never include more than a small and special group of "intellectuals." They point out the ridicule and abuse which has often been heaped upon painters of the *avant-garde*. Ridicule and abuse, of course, are the outward manifestations of ignorance. But nowhere have I heard more ridicule and abuse than that which is heaped upon the public by the *avant-garde*. It is a sign, I suppose, that neither side understands the other.

The most effective method of arriving at understanding would be to have good paintings from these schools in the homes of thousands of people. Do I hear somebody say that the public won't buy them? How does anybody know? It has never been

tried. For some reason that I have not figured out, the new, experimental work in every exhibit — the work of those very persons who have the poorest opinion of public taste, who beat their breasts most bitterly because they are not appreciated — is always priced the highest.

These people who express contempt for the great majority of their fellow men should not and, I think, do not expect to find a broad market for their work. Nor do they deserve one. They have run away from the realities of life, among which is the age-old truth that an artist is the interpreter of life to his fellows.

One of these artists who has no hopes for public taste (and who places his simplest sketches on sale priced at $100) said to me that the idea of an artist living from the sale of his work was ridiculous, that no really creative person could hope for general acceptance or monetary reward. It seems to me that this notion would have been startling to any number of fairly creative fellows: Leonardo, or Dürer, or Hogarth, or Renoir. It is true that this man could name many great artists who were not financially successful. Can he name one who accepted financial failure happily, as a sure mark of genius, as he does?

Public taste is not what artists could wish. It never has been. It is very probable that painting will never be as well understood or as deeply appreciated as persons who devote their lives to it want it to be. It is likely that there will always be the woman who decides not to buy a painting because it doesn't match her sofa, and the man who is too busy making money to look up and see a painting — or to see life, for that matter.

The only answer painters have is to touch as many lives as possible, by placing their paintings before as many people as possible, and by pricing them within reach of everyone. The painter's usefulness is increased every time someone finds in one of his paintings the meaning he tried to put there, and is able to buy it. And when that happens often enough, the painter is able to live by painting.

A painter who complains about general public taste and at the same time prices his pictures at $1000 and $1500 and higher, seems to be indicating a belief that only people with a great deal of money are apt to have enough taste to appreciate his work. It

should be self-evident that the reverse is at least as often true. There are a great many wealthy people with the taste of an oil-rich Oklahoma Indian. And there are myriads of people who have found the race to get money distasteful, whose cultural interests are broad, and whose aesthetic judgment is admirable.

It has been my own experience, in fact, that the closer a man gets to money, the less apt he is to be interested in painting. If my own exhibits indicate which people in my community are interested in painting—and I like to think that they do—then it is not the wealthy man, but the creative man that has the real interest. Bank presidents and fertilizer company presidents (we have fertilizer companies in Norfolk) and ship-yard presidents (we have ships) and railroad presidents (we have railroads) do not visit my shows. Chemists, and engineers, and college professors, and architects, and musicians, and writers, and doctors, and lawyers come in droves. The first painting I ever sold was to a mechanical engineer, and at my first exhibit the best painting went to a medical college dean. The painting I liked best out of my most recent show was purchased by a young organist of a local church. He paid $50 for it, and no matter how much he wanted it, he couldn't have paid $150.

The wealthy in my town have paintings. But they buy them on a different basis, I think. I visited Mr. Blank, the financier. He showed me his paintings. "This," he said, "is a Renoir. And this is an original Matisse drawing." His attitude was that of a man who has made a sound, gilt-edged investment, not that of a man to whom painting could be a moving force. Even if his choice of paintings was guided by his own aesthetic standards, which it is not; and even if he were willing to pay $1000 for a painting he liked by an unknown contemporary painter, which he is not—even then his purchase would not make much difference, because there are not enough of him.

As a matter of fact, the market for abstract, non-objective and other paintings of "modern" schools lies not among the wealthy, nor even among the prosperous. Its devotees are most numerous among the younger groups, who do not have a great deal of money. They are people of college background and some degree of sophistication—they are college instructors, or librarians, or

musicians, or scientists. They live in "modern" houses; they listen to Hindemith and Bartok and Schonberg; they read T. S. Eliot and Dylan Thomas and Christopher Fry. And they are the loyal group in every community which flies to the defense of modern painting. Their belief in it is genuine. If these paintings were within their reach, they would buy.

Painting what he believes in is the artist's obligation. Following his own ideas, wherever they lead him, is his only reason for being a painter. There is no pressure on him to do otherwise. But no matter how much a painting is worth, aesthetically, the fact is and always has been that in the economic sense a painting is worth what someone can and will pay for it, and if you are to live by painting you will have to accept the idea. It seems to have been forgotten only in the field of art. In every other field it is accepted as a matter of course.

V · Where Shall You Work?

THERE IS a strange compulsion which causes artists to go away somewhere to paint. Artists who live in Norfolk travel to Cape Cod every summer, or to Rockport, to paint pictures. In the winter they go to Taos, or Taxco, or Paris.

Not long ago I judged an art show in West Virginia, limited to work by West Virginia artists. West Virginia is a beautiful and picturesque state. In the exhibit were paintings of the Maine coast, of Cincinnati, of Mexico, of dozens of other places. There were still lifes, figure paintings, abstractions. There were not five paintings which reflected in any way the magnificent material for painting that I had been seeing all day as I drove through the state to get to the exhibit. Painters seem impelled to leave wherever they are, and go somewhere else, before doing any work.

During my experience as a painter this same strange thing has happened over and over. In Galveston, I painted the shrimp boats; the scaly, ramshackle Victorian houses; the seine fishermen along the beaches; the somnolent, heat-shaken streets with their tattered palm trees — and learned to my surprise that no one had ever done it before.

In Durham, I painted the rolling red clay land; the tobacco fields; the cabins of the tenant farmers; hog butchering, with the

first snow sifting down on the stubble fields; and many another facet of the life around me. When I had my first one-man show at the state art gallery in Raleigh, editorials in papers as far away as Asheville, clear across the state, rejoiced that someone had at last painted the story of Piedmont Carolina.

I decided on Norfolk as a permanent home because it seemed to me that here was material for a lifetime of effort: the sea, the shipping, the brown marshes, the beautiful old houses, the rich and pleasant farmland. Nearby were Yorktown, Williamsburg, Richmond, the Blue Ridge. And the people — as they do every-where — the people carried in their faces the infinitely varied shadings of the light and shadow of life.

When I had been painting in Norfolk less than a year, I found that the things I was doing were attracting wide interest and attention — because nobody had ever done these things before.

This is a big country — a magnificent and varied country. Ninety-eight per cent of it has never been touched as material for an artist's brush. Every square mile of it could provide challenge and inspiration. And yet almost every village has produced at least one painter who went away to New York, or Woodstock, or Santa Fe, and left behind him the one place in the world he understood most and loved best.

If you can paint a good picture in New York, you can paint a good picture in Flowery Branch, Georgia, or in Guthrie, Oklahoma, or in Chillicothe, Ohio. You gain no ability by going away. The opportunity for success as a painter has nothing to do with the geographical location. It lies within you, wherever you go.

Perhaps you are thinking at this point, "These things may be true for a landscape painter, but suppose I am not a landscape painter." Or perhaps you are thinking, "Regionalism was dis-credited years ago."

Let's take these questions up one at a time. Whatever your interest in subject matter, whether it be figure painting, still life, nature, or what you will, your chance at original observation is better if your surroundings are your own. Are you moved to put social protest into your painting? There is material in Mississippi or Texas, or in your own township. Are you an expressionist? There is significant pattern of life in a Kentucky camp meeting or

a New Jersey factory. Do you abstract from nature? Abstract the crawling grace of South Carolina watermelon vines, or the spiny bulbed pulpiness of an Arizona cactus. Wherever you find yourself, gather the truth about you with your eyes, give it form, and make it your own.

And do not be afraid of regionalism. The universal truth that artists try to express must always be achieved through a crystallization of life as it appears to the individual. What is possibly the most significant work of fiction of the 20th century, James Joyce's "Ulysses," has as its subject one day in the life of a man in Dublin. William Faulkner won the Nobel Prize for Literature because his writing expresses moving and universal truth — and yet his source of inspiration for a lifetime of great work has been found in one county in Mississippi. Charles Burchfield has expressed American life in his paintings by putting down, with sharp insight, the things around his home in Buffalo. John Marin found endless room for spirit and imagination on the Maine coast, as did Ben Shahn in the dark web of the city.

There can be no painting which does not find its source in some aspect of life. And whether the painting is good or bad cannot depend upon the subject matter, but always upon what is done with the material — and that depends upon the painter.

There is another objection that has been raised to the idea of a painter remaining in his own territory — the argument that one finds inspiration in new surroundings. There is very likely some truth in this for some people. If you feel it is true for you — if your own surroundings seem drab and uninspiring, and you want to get away to more exciting territory — then do so. But do not go to an artists' colony.

Do not go to an artists' colony for many reasons. As mentioned in Chapter III, there is the danger of influence, the danger of insulation from the world, the danger of wasting time in talk — and, from a practical standpoint, the lack of opportunity for making a living. There are dozens of places where artists swarm like bees, cut off from any possible market that could be expected to support one-tenth of them — and yet there are thousands of places — tens of thousands — very much the same kind of places, where an artist painting a picture is as rare a sight as a bee living alone.

New York is the Mecca most painters look toward. It is true that New York is the hub around which American painting revolves. But remember it is not the hub of a wheel, but its rim, which touches the ground. If you become an outstanding painter, your work will find its way to New York — but you will not become a better painter by going there yourself.

The emphasis in New York is upon "recognition" — getting into the big shows, getting good notices from the critics, getting membership in a good gallery, selling work at good prices. Because of this fight for recognition, and because it is so sharp a struggle, the tendency is to think of "recognition" as the principal goal. It is desirable, certainly — pleasing to the ego, and helpful to the pocketbook. But the only worth-while goal is painting what you believe in — following your own particular star.

Everyone agrees that the artist who paints with one eye on the market is betraying his talent. The artist who paints with one eye on the juries and the critics is no better. The painter who says, "I will paint so that they will be *forced* to recognize me," displays ambition; but the man who says, "I will paint what I believe, and I will do it no matter what happens," displays integrity.

Becoming a good painter is a thing you must do alone. Artists, by flocking to New York to work, and by concentrating their efforts toward recognition in New York, have divorced themselves from their greatest potential audience, geographically speaking. By pricing their pictures so that only persons of considerable wealth can buy them, they have cut themselves off from their market in an economic sense. By huddling together in New York, and in art colonies, they have inevitably lost contact with the realities of American life, and thus have maimed themselves aesthetically.

I intend giving no list of suggested places where you might work. But, as examples of the innumerable possibilities, here are a few spots that, it seemed to me in travelling about during the last year, offer opportunity both as to subject matter and market.

Gatlinburg, Tennessee, is a village at the entrance to the Great Smoky Mountains National Park. Within a few miles are the most magnificent mountains in eastern America. Around Gatlinburg live mountain people who retain the sharply chiseled features, the

speech, and the customs of their forbears, the pioneers who settled these hills in Elizabethan times. They have developed a folk art and folk music of simple charm. A few miles away is an Indian reservation, where live those Cherokees who defied the white man successfully, when all the rest of their tribe was moved west.

Gatlinburg, although cluttered now with tourist cottages and hotels, retains some of its charm. The Pigeon River brawls beside its main street, and a mile away in any direction the mountains are as they always were — alive with dogwood, flame azalea, laurel, and rhododendron in the spring; heavy with the lush green of deep forest in the summer, or hazy with the strange blue mist that gives them their name; ablaze with color through the long Indian summer that comes in October; and white in winter with snow which makes clear the noble and rugged architecture of their ridges and ravines.

If I were a young landscape painter I would go to Gatlinburg and find a cabin in the country near-by, along the highway. There is subject matter for a lifetime. And, as for market, past my cabin would come everyone of the hundreds of thousands of people who visit the Smoky Mountains each year, because Gatlinburg is the only entrance to the park from the west. I am pretty sure that I could sell enough paintings on week ends alone to keep me busy. But if that were not enough, I would get an agent in Knoxville, and in Asheville, both within a few hours' drive, and both large enough to provide an active market.

If I were a young painter of abstract art, I would take another course. During 1953, while at work on a commission, I spent a month in Bronxville, a suburb of New York. I suppose there is no place else in the world where there are quite so many well-to-do people living in a concentrated area as there are in Westchester County. Pelham, Scarsdale, New Rochelle, White Plains, Rye — in each of these communities and many others there are thousands of home owners in an income group which permits luxury buying. These people are more sophisticated than the average, more ready to accept the new, more in touch with contemporary movements in painting.

On the main street of Bronxville was a bookstore with a large lending library which attracted a steady stream of customers.

There was also, a little way down the street, an art gallery, which attracted relatively few. The art gallery had some good work in it, but most of it was priced beyond the reach of even the average Westchester family. If I were a young painter of the modern school, I would find agents in Bronxville, and in Rye, and in Scarsdale, for example — agents like the bookstore, where many people come. By experimenting with prices, using the methods described in Chapter VII, I would find a steady market for my work.

This would be easier than finding a 57th Street agent, would reach an infinitely greater number of people, and would result in more sales. Few Westchester housewives visit New York galleries regularly, but almost every one of them walks down the main street of her own town many times a week. And almost every one of them is a prospective purchaser for paintings she likes, at prices which she can afford.

Because it combines the exotic flavor and color of a border city, the crisp silhouettes of rock-bare mountains and the limitless horizons of the desert, El Paso is a city to remember. Whether a painter is interested in the people, or in the land; in the social forces at work, or in the patterns of sand and rock, the material is there for a lifetime.

And the market is there. It consists not only of the people of Texas, who are proud and prosperous, but also of the countless others from everywhere who stream through the city the year around.

The list could be lengthened indefinitely. But the answer is a little different for each person. Whether you are in Biloxi or Utica, in Wheeling or Joplin, there is room for a painter who works hard, who produces work which has meaning, and who is willing to sell it for prices which people can and will pay.

It may seem unglamorous to simply dig in where you are, and try to become a successful painter. It's not like the stories have it. There is something about going off to the city to make a name for one's self, which appeals to one's sense of the dramatic. There is something about becoming a member of an art colony which is apt to make one feel that he has arrived, when he has only started — and possibly down a dead-end road, at that.

In spite of what so many people think, there is nothing glamorous about being an artist. It is hard work and lonely work, and its satisfactions, although very real, come from the doing of the work, and not from anything else. You do not become a better painter by joining any group, or by going anywhere at all. You become a better painter by painting, and by thinking about painting, and by experiencing life, and by reacting to it, and by painting again.

If you have it in you to become a good painter, you can do it in one place as well as another. You can become one where you are right now.

VI · Your Agent

WHEN I BEGAN to try to make a living by painting, on the beach at Galveston, I worked from Monday till Saturday night, and when Sunday morning came, I tacked the best of my paintings (they were all pretty bad) on the front of my cabin, which faced a busy road. I put prices of $2 and $3 on most of the pictures. A few were $5.

Every Sunday I sold five or six. I was thus making between $15 and $20 a week, and since that was all the money I had, I lived on it, after a fashion.

Within a few weeks, a problem arose. I learned that people had been coming to the cabin during the week while I was away painting. They came to see what I was doing, and many of them, I thought, might have bought a painting had I been there to show them my work. I needed these sales to augment my income, because I was getting tired of oatmeal as a steady diet, and eventually I would have to buy a new shirt.

I decided I needed an agent. And yet there was this to think about: An agent would have to be paid a 33⅓% commission, which seemed like a lot. And unless the agent sold half again as many pictures as I had been selling, my income would actually be less, instead of more.

Then one Sunday it rained, and sitting in the door of my cabin looking at the drizzling sky, and facing a week during which the oatmeal was going to be rather watery, I decided an agent was essential.

Since that time I have had several agents, as I moved about the country. Some were better than others. But each of them has been worth the 33⅓% commission that I paid him.

The basic reason for having an agent is, of course, the fact that you can't paint all day and at the same time deal with customers. But in addition to this there are many things an agent can do for you, and most of them are things you cannot do for yourself. Your agent can approach prospective purchasers and attempt to interest them in your work. In doing this, and in all contacts with prospects, he (or she) can discuss your paintings, pointing out merits that may be there. He can give facts about your background, mention outstanding work you have done, and honors that you have won. He can quote favorable comments about your paintings, and through the use of all these facts can create an acceptance for your work in the frame of reference to which your recognition as an artist entitles you. All of these things are legitimate as a means of influencing purchasers, and they are interesting facts which purchasers are glad to know. And all are things that you, yourself, obviously cannot do.

In addition to the basic job of selling your paintings, your agent can help you in other ways — by keeping your accounts straight, for example, and by sending out bills when money is due you. If you are as forgetful as I am, an agent can be very useful, also, in reminding you of things that need to be done. For all these reasons, almost as soon as you begin painting you will need to find some person to act as your agent.

Eventually, you will want a New York gallery, but this is a special problem, and is discussed separately in Chapter XI. To begin with, you will do best to concentrate your efforts in your own territory, whether it be Bronxville, New York or Gallup, New Mexico.

This does not mean that you should look for a local art dealer, or for a local gallery to exhibit your work. Not necessarily. In selecting an agent you should consider any art dealers that have

galleries in your community as a possibility, and decide whether or not one of them would be a suitable agent.

Visit the gallery. Is it centrally located as to shopping districts, or if not, is it on a main thoroughfare with convenient parking facilities? How many people come in? What kind of people? What is the range of prices on the work exhibited? Does the gallery seem oriented toward a mass market, or does it seem directed toward selling work in a high-price bracket, with the market thereby restricted to the relatively few who can spend a large sum for a painting?

It has been my experience that the art galleries in most communities, even though they are often operated by very fine people, do not satisfactorily meet the tests posed by these questions, primarily because they do not attempt to direct their appeal toward a broad market. While it might be too unkind to say that they operate on a basis of snob appeal, some of them seem to come very close to it.

Whatever the reason, the fact is that they attract relatively few visitors, and their efforts are directed toward attracting, not the general public, but only those relatively wealthy groups which they consider logical prospects for their paintings.

This kind of gallery is not suitable for your purpose. You want your paintings where many people of all classes of society will see them, and you are going to sell them at prices which such a gallery would very likely consider too low to afford them a substantial profit.

You may very possibly find, also, that such galleries are not interested in promoting your work unless you are a well-known painter. This is not necessarily a matter of the quality of your work. Early in my career as a painter I attempted to interest a gallery in selling my paintings. Nobody had ever heard of me. The paintings were priced low, and the gallery turned me down. Later on, some of these same paintings were hung in some pretty good juried exhibits, and at least a few of them were sold through a New York gallery.

Most galleries like to feature work by artists of established reputation, because the artist's name helps them sell his work. A respected New York dealer, by sponsoring a new and unknown

painter, can bring him prestige. In a smaller gallery, in a smaller city, the shoe is on the other foot. The fact that they display work by well-known men gives the gallery a certain prestige — a prestige which they are often unwilling to risk by sponsoring an artist who has not already established a reputation.

So you may find, in the beginning, that no art gallery wants your work. And if you want to make a living by painting, you may find it much better, anyway, to have an agent with a different outlook, and a different horizon.

You must display your work — this is repetition, but it is vital — you *must* display your work where as many people as possible will see it. This means not only interested people, but people in general — all kinds of people.

The law of averages is a funny thing, but it works. I used to sit in front of my cabin at Galveston on Sundays and count the cars that came by. As I finally averaged it out, about one car in fifty would stop, and someone would get out to look at the paintings. And of those which stopped, about every eighth car would have someone in it who would buy a painting.

On a warm, clear Sunday, when more than two thousand cars came by, I would sell five paintings, or six. On a cold or cloudy Sunday, when about a thousand came by, I would sell two or three paintings. It was uncanny, how closely it worked out. Given the number of cars that were going to pass my cabin, I could have said in advance almost exactly how much money I would make that day.

This principle is recognized in all kinds of merchandising. In determining the desirability of a store building, it is an accepted practice with real estate brokers to make traffic counts. If ten thousand people walk past a certain store, the rent is higher than if six thousand go past, because the man who rents the store in the busier location will inevitably sell more pants, or cabbages, or tennis rackets, simply because more people pass by. And it works if he sells paintings, too.

In addition to having lots of people see your paintings, you need someone to sell them who is intelligent and cultured, yet who retains the common touch. Where do you find a location which combines considerable traffic with the presence of this kind of

person? I have found it most often in a bookstore.

Bookstores attract a fairly steady stream of people, and have the relaxed, friendly atmosphere that invites browsing. They are almost invariably operated by persons of culture, many of whom already have an interest in painting, and all of whom are temperamentally suited to the task of selling paintings.

Since bookstores these days are not an extremely profitable enterprise, their owners are often receptive to the idea of selling paintings as a suitable addition to their stock of merchandise — and one which promises additional income. Bookstore proprietors know their customers and are aware that people who read are more apt to be interested in painting than people who do not read.

Another fact which often makes a bookstore an interested and effective agent is this: The average sale in a bookstore is not large. Books sell for $3 to $5; rarely for more than $10. And so, to a bookstore, the sale of a painting for $30 or $50 or $100 is a relatively important matter, and a thing in which they can develop considerable interest and enthusiasm.

One objection you may run into is that most bookstores are pressed for space. This need not be a serious stumbling block. If enough wall space can be found to exhibit one or two paintings, which can be changed often, the rest of your collection can be exhibited as shown by the sketches on the following pages.

In addition to this display, one or more paintings can usually be used in the store windows.

For all these reasons, you may find the bookstore in your community the best outlet for your work. But since each city and town varies in problems and in opportunities, this will not always be true. There are several factors that may affect your choice.

In many sections of the country, tourists are a considerable potential market. An establishment which caters to tourists has the advantage that each day it attracts new people, a certain number of whom will be interested in painting. Not every shop which sells to tourists is a suitable outlet for paintings. In many of them, the quality of the merchandise is low, and often in execrable taste. But some few places handle articles of real merit, and are operated by people who could sell original art quite successfully.

If you live in a rural area, you will need to find agents in the nearest cities; but you may also find that a small exhibition building along the highway, with parking space, and signs at a distance in each direction will result in considerable sales, if there is someone available to keep watch over it. When I lived in Manitou Springs, Colorado, my paintings were sold through a gift shop in the swank Broadmoor Hotel in Colorado Springs, but I also kept a display of paintings in the entranceway of my house. There was a bell to be rung, and unless the bell rang, my wife did not need to bother with the exhibit. The house was half a mile up a steep canyon road, and only a few tourists came by, because this was during the war. But quite often, when I came in at evening my wife reported a sale, and one memorable day she sold three paintings.

If you live in a rural area near a well-travelled thoroughfare, consider the possibility of a roadside exhibit, but only as a supplement to your other outlets. Such an arrangement can be helpful, but it is usually seasonal, and the people attracted by it will usually be interested in low-priced work.

How large a town does it take to support a painter? No exact answer is possible, but it has been my experience that a city of 50,000 people constitutes a fairly satisfactory market. It is doubtful if a town much smaller than that would be large enough to give an agent sufficient opportunity, and even in a town of 50,000 or 75,000, you may need to find agents in two or three additional areas in order to reach enough interested persons.

In larger cities, from 100,000 up, the problem is different. The audience is available; the question now is merely one of finding the proper outlet for your work. You may not find the arrangement you want right away, so do not commit yourself to any long-term agreement until you are certain you have found the right place and the right person.

This may be, as I have said, a bookstore. It may possibly be a gift shop, although gift shops do not usually, I think, attract a broad enough audience, except in tourist areas. It may be a department store, or a music store, or a good furniture store, or a picture framer's shop. It should not be, usually, an art supply store, because while these places are almost invariably willing to coop-

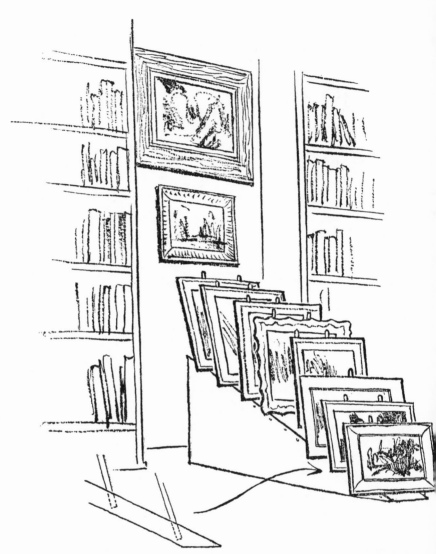

When space is limited so that only two or three oil paintings can be displayed, the rest of the collection can be placed in a rack made by boring holes in a 2″ board at the proper angle for the insertion of supporting dowels. The sides of the rack can be of plywood. Spare dowels of various lengths can be kept on hand to accommodate paintings of different sizes. The paintings should all be equipped with wire for hanging, so that they may easily be interchanged with those on the wall.

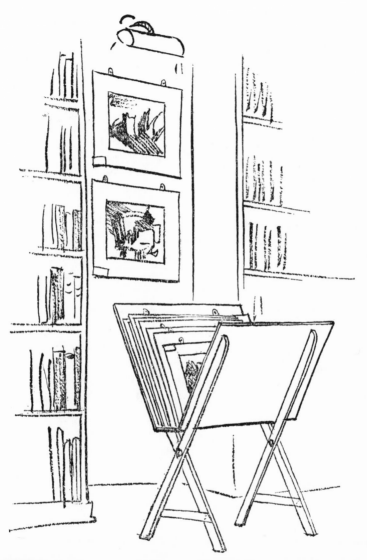

A method of displaying watercolors in limited space. The rack is made of 1" x 1" strips and plywood, painted dark gray. Each of the matted paintings has two gummed cloth hangers spaced to fit the hooks on the wall, so that any of the pictures may be hung up for inspection in a matter of seconds. There is a card clipped to each painting giving its title and price.

47

erate, and most of them, in fact, have a number of paintings around that people have placed with them, they do not have the type of customers who will buy paintings.

Suppose you cannot find a store that meets your requirements and that is interested in selling your work? Then you should look for an individual with the proper qualifications and place your work in his (or more usually, her) hands.

This may seem to break the rule that your pictures must be seen by as many people as possible, but in actuality it does not. In two cities, I have had agents who were not connected with any business establishment and both were very successful. Both were women with a wide circle of friends and considerable initiative, who handled my work from their homes.

This did not mean, however, that the paintings were not widely seen. Local picture framers, since they derive quite a bit of business from the sale of my paintings, were glad to display a few, usually in their windows. The paintings so displayed were changed every few days by my agent. Phone calls and conversations at social gatherings developed prospects which these agents followed up by making appointments for personal calls. Taking a portfolio of watercolors or a couple of small oils into a prospect's home, discussing decoration and wall spaces, and the size and type of paintings that might be suitable, these agents found many women who appreciated their help and suggestions. Quite often, paintings were left in the prospect's home for a few days on approval, and this proved very successful. When someone has lived with a painting for a time, he is often unwilling to give it up again.

Your agent, whether or not he has a place of business where your paintings are displayed, should also call on businessmen, lawyers, doctors, and bankers—always by appointment—and show them paintings in which they might find an interest. My agent called on a local bank to show its president a watercolor in which the bank's main office appeared. This visit resulted not only in the sale of that painting for $35, but also led to a commission for a series of more than thirty large watercolors to hang in the bank's various branches, at a total price of more than $9000. As a further result, when the bank built a new office, they asked me, as the only artist they knew well, what I thought about a mural. Well,

when a fellow comes along who wants to go elephant hunting, and mentions it to a fellow who only has a bean-shooter, it's just common courtesy to refer the would-be elephant hunter to some people who own rifles; so I gave the bank officials the names of some artists I thought would do a good job. In the end, however, they gave the commission to me, and I worked for more than a year carving a panel seventy feet long and seven feet high, although I kept being surprised to find myself doing it. You never know.

It boils down to this: The efforts of an imaginative and alert agent will get your work before the public and, more particularly, before those people who are the most logical prospects for the kind of work you do. This takes initiative and energy. Your agent must not be a person who sits back and waits for business to come in. Each painting you do should suggest possibilities which the agent then acts upon.

This does not mean that your agent is a source of ideas for you. On the contrary, your work is a source of ideas for him. When I paint a picture of a freight yard because the color of the day, the low clouds, the blacks of the rust-stained cars, and the fiery bright accents of the red switch signals appeal to me, I want my agent to show it to railroad men, among others. But if he says, "I believe we could sell another railroad subject to the N & W," I throw whatever is handiest at his head.

Since the agent you select will have much to do with whether or not you succeed, your selection is a most important matter. What kind of person will make a successful agent for you?

First of all, your agent must have a sympathetic understanding of your work. If you paint abstractions, you will need a different person, possibly, than you will want if your paintings are in a realistic vein. If you are a non-objective painter, your agent should be a different person, probably, than would be selected by an expressionist. At any rate, you must be sure that the person who represents you understands what you are trying to do, is enthusiastic about it, and is able to discuss it intelligently and constructively.

As to personality, the ideal agent is, as has been said, cultured, without a trace of snobbery; personable, without being stuffy; and intensely interested in people and in painting, without

gushing over either of them. Your agent should be able to make friends easily, and should be able to develop an understanding relationship with all of the many kinds of people who will be interested in your work.

Avoid becoming entangled with an agent who displays that panting, wide-eyed enthusiasm which at first blush may seem desirable, but which in the long run will smother you, and everyone. Avoid, too, the agent who is interested in selling your paintings only because it offers a chance to make some money. This attitude will be reflected in actions, and the public may come to feel that money is your primary object, too. And, finally, avoid the dominating agent as you value your life. These people are the ones who "know" what you should do, and attempt to direct your interests and dictate the nature of your work. They are entirely sincere, and devastatingly sure of themselves — but they will drive you mad, because they never change, and never give up.

Finding the agent you want may take a little time. You may not discover the proper one without a couple of false starts. But once you find the person with whom you can work successfully, you will know it, and such a relationship can develop into a very pleasant and satisfying part of your life as a painter.

Paintings are, practically without exception, placed with agents on consignment. That is, the agent pays you no money until a painting is sold, and then pays you its price, less the agreed-upon commission. This commission is usually $33\frac{1}{3}\%$, and it should be paid to the agent on every painting sold in the territory in which he represents you, even in cases where you yourself make the actual sale, unless there is an explicit understanding as to exceptions, as, for example, any commercial work you may do. If your agent, on the other hand, splits his commission with someone else you should still receive your full $66\frac{2}{3}\%$ of the sale price.

Prizes are not subject to commissions, and while it is generally accepted practice among large galleries to demand a commission on works sold by the artists from competitive exhibits, and on purchase prizes, it is not practical or necessary to have this kind of agreement with an agent who represents you on a local or regional basis.

In case you have an agent in a near-by city, and also sell your

work through some arrangement like the roadside exhibit mentioned earlier in the chapter, a commission should be paid on everything except what is actually sold from the exhibit. Such an arrangement will not cause difficulty if the two outlets are separated geographically by a reasonable distance, because they will attract a different type of clientele. In case they are close enough to create a confusion of interest, the arrangement should not be attempted.

The agreement you make with your agent should be in writing, so that there will be no misunderstanding. The simplest method of handling this is by writing a letter to your agent, setting forth all

Title	Medium & Size	Date finished	Delivered to	Price	Sold & Paid	Amount	Remarks
Fisherman's Home	W.C. 14 x 20	4/17	M.A. 4/23	$35	5/27	$23.33	
Buried Alive	W.C. 14 x 21	4/20	M.A. 4/23	$60	5/20	40	Bought by B. Craver
Christ at St. Lukes	Pencil Drg 7 x 9½	4/21	M.A. 4/23	12	4/30	8	Sketch for W.C. asked about by Mr. H—
Ripening Corn	W.C. 16 x 20	4/22	M.A. 4/23	50	7/2	33.33	Exhibited 5th Annual Mem. 5/10
The Smell of the Earth	Oil 16 x 20	4/30	M.A. 4/30	75			
Mending Harness.	W.C. 32 x 40	4/30		100			Sent to Mint Museum 5-7
Wythe House Garden	W.C. 20 x 30	5/2	Wmsbg 5/4	100	6/1	66.66	

Part of a page from a painter's journal, which enables him to keep a record of his work and his income. The author uses a ten cent composition book for this purpose.

the points covered by the agreement, and then having your agent write you a letter of acknowledgment, agreeing to the terms in your letter.

In turning over paintings to your agent, you should get a receipt, giving the title, size and selling price of each painting. When your

agent sells a painting, he should make out a bill of sale in duplicate, giving one copy to the purchaser and retaining one in his files. Samples of both these forms, as developed and recommended by Artists Equity Association, are given in the Appendix.

You can keep a record of all your paintings in a single journal, in which you list each painting as you complete it. When you turn it over to an agent, this can be noted in the proper column. When it is sold that can be noted. A sample page from such a journal is reproduced above. From such a record, it is possible to keep track of everything you do with a minimum of time and effort.

Let me close by repeating that the right agent — someone you can work with in harmony and understanding — is an invaluable help toward your success as a painter. Pick out that person carefully, and much of the worry and most of the fretful details of your work are gone. You can devote your whole time and energy to doing the best paintings of which you are capable, to your advantage, and to the advantage of the agent who represents you.

VII · Pricing Your Work

How MUCH is one of your paintings worth? That is the one most difficult question to answer, and yet on its answer depends your ability to live by painting. The difficulty is that you are faced with the problem of expressing aesthetic quality in terms of money, and that is, of course, impossible. No one can put a dollar value on an emotional experience.

The only solution is to separate the aesthetic value of your painting entirely from its cash value. That is what people are driving at when they talk about "Art for Art's sake." That is what artists who say that they "will not compromise their ideals in order to make money" have in mind.

But the one best method of separating artistic merit from price is by painting with no regard to the market. (This enables you to do your best.) Now make a clean separation. Sell your work at what it will bring in the market, regardless of its possible artistic merit. (This enables you to make a living.)

It may turn out later that you have sold a masterpiece for a small sum. Here is a specific example. A painter sold one of his watercolors for $50. About two years later it was purchased from the owner by a nationally known art gallery for $500, to become part of its permanent collection. How does the artist feel about it?

He is immensely pleased, and he ought to be. He lived for a week on the $50, and during that week he painted. Now there is an indication that his paintings may have in them some of the emotional validity he has been trying to put there. If he had put a price of $500 on the painting, and on all his other paintings, he would not be painting today, and painting is what he wants to do.

Aside from all other considerations, selling your paintings at prices which enable you to sell everything you produce has one decisive advantage. It works. You can make a living. You can paint as you please on a full-time basis. These two things are all any artist wants.

How do you go about pricing your work on this basis? Here is a method of doing that.

Whatever your level of accomplishment, you will find that your work can be divided into four classes. There is a certain part of it not up to the standard you set for yourself. This you must discard. Then there is a group of work which is just adequate. You are more than usually dissatisfied with it, and yet it has some merit. Let's call this group which barely cleared the hurdle, "fair."

There is a larger category, which is workmanlike to a degree, and which is generally characteristic of the kind of work you are able to do. Let's call this group, for purposes of identification, "good."

Once in a while, one of your paintings will develop into something which you feel is better than you really know how to do. You will feel that you almost had something. There won't be many of these, and since they are the best you've done, let's identify them by that word, "best."

Now, having discarded the failures, you have three classes of work: fair, which is below your usual standard; good, which is about your average; and best, which is the way you wish you could paint all the time.

The time involved in producing any of these works cannot be considered as a factor in deciding upon where it belongs. Only its success as a painting can have any weight.

Put the "fair" work in one group. Put the "best" paintings in another. Now take the "good" work, which will be the largest group, and try to decide on a scale of relative value for each pic-

ture. If there is someone whose judgment you respect, get him to help you. It is better if this person is a layman, because what you are trying to determine now is not artistic merit — you have already grouped the work as to merit — but market value.

The factor of size can now have some consideration. A large painting may not have taken any longer to complete than a small one. It may have no more merit. Generally speaking, however, a purchaser is more willing to pay a high price for a large picture than for a small one of the same quality.

When you have the "good" group arranged in an order of relative value, select a painting from about the middle of it — an average example of your work. Now comes the vital question: How much will people readily and consistently pay for a typical example of your work? This does not mean the highest price someone might occasionally pay. It does not consider how similar work is priced by other painters. It does not consider how much money you think a painting is worth, or how much money you would like to make. What is to be decided here is the price that will enable you to sell this painting and others like it, *readily and consistently.*

The only method of finally arriving at this answer is by a process of trial-and-error. But since a beginning must be made without this knowledge, you will have to make an informed guess. The nature of the market has some bearing on this price. An example of this is the fact that, in pricing my own work, I have found that in Norfolk, watercolors priced from $50 to $75 sell readily, but that those over $150 move very slowly. In Williamsburg, where the paintings are for sale in the Craft House, and are seen primarily by persons who are visiting the restored Colonial capital, the average selling price is somewhat higher, with most of the paintings selling at around $100 and some for $150 or more. This, I feel sure, is because the Williamsburg market represents a higher income group.

Another factor that must be considered is the medium in which you work. Oil paintings can ordinarily be sold at higher prices than watercolors or casein paintings. Drawings must be sold at a lower price than either of these.

The nature of your subject matter has a bearing on price, as does the style in which you work. This is not as great a factor as might be imagined, however. It is true that at the present time

more people will be attracted to realistic work of a romantic nature than will be attracted to abstractions, or to expressionist painting. But this is compensated for by the fact that although the number of people who understand and want "modern" painting is smaller, these people are more apt to be deeply interested in the work they like, and more willing to buy. A great many of the people who admire realistic painting have no convictions about, or interest in, painting. But almost everyone who likes "modern" painting has strong feelings about it.

Having considered all these factors, decide on a price for your average painting. Let's say it is $25 for a watercolor, or $40 for an oil. Now take about six paintings from your "good" group that seem slightly more salable and price them at $5 to $10 higher, and six slightly less salable, and put these at $5 and $10 lower. Let's say the lowest-priced painting is $15 and the highest-priced one is $50. Put them in the hands of your agent and see what happens.

If he sells the paintings at a fairly steady rate—two or three a week—your prices are about right. If most of the paintings sell within a short period, your prices can be raised. But if three or four weeks go by and no pictures (or only one or two) are sold, you must face it, your prices are too high for the market you have.

Based upon the results of the first two months or so, you can begin to gauge your price scale more intelligently. If the sales are satisfactory, *keep the average price of new pictures at about the average price of those sold.* If you need additional sales, put some of your new paintings in at lower prices. If you are selling faster than you are producing, put new paintings in at a little higher prices, but keep some paintings available at *low prices* too.

Keeping some paintings available at low prices is important. Fifteen years ago, my watercolors were priced from $15 to $40. Now I often sell a painting for $100 and occasionally for $300 or more. But I find that keeping some pictures priced at $45 and $50 is valuable, because if some of my prospective customers begin to think of my work as too expensive for them, they will lose interest in it, and the whole philosophy of this method of selling is to attract the interest of everyone, regardless of his income level.

As your pictures begin to sell, you will find that certain phases

of your work have special appeal to the public. A young painter whose primary interest was in doing large oils in an expressionist style, utilizing figures and objects related to the sea, had filled dozens of sketchbooks with lively pen drawings of source material for these paintings. His oils were out of reach of most people because of their size and price, but he found that these drawings, matted but not framed, sold at a tremendous rate, at from $5 to $20 each. And a watercolor painter, whose primary interest was landscape, happened to do a few low-keyed interiors, and discovered that they were in far greater demand than his usual work. I know that when I happen to have a beach scene, or a painting of the marsh country along the coast, it will be the first thing sold out of a collection.

Once a painter has discovered the kind of painting that people want most from him there are two courses possible. One is that of the hack, who begins to specialize in the kind of thing he knows will sell. A person who does this is betraying both the people who believe in him and his own talent. The course of the artist is to continue to search for subject matter that interests him, and for forms of expression which will give his painting new effectiveness.

When you come to price your work is the moment to consider what will appeal to people, on the basis of what they have shown preference for in the past. You will find some paintings each time that come within the category of what people have wanted most, and (following the law of supply and demand) you price these paintings higher, because they are in special demand.

There is a distinction here which is vital. It takes a certain amount of fortitude to hew sharply to the line of creative effort, when you know that you can repeat a successful formula and sell the result — especially when you need the money badly. And there will be times, especially at the beginning, when you will need the money. It is at this point that you will make the decision which may very possibly determine your future as a painter. There are many competent painters who have succumbed to this temptation — and have thus given up hope of contributing anything new or significant to the art of painting.

This is not to say that you should avoid any subject matter or type of work simply because it is popular with your buyers. The

criterion, of course, is not whether they like it or dislike it, but whether you feel impelled to do the work for its own sake. Every great artist becomes known for work with certain characteristics; it is inevitable that he should — Burchfield for his old houses — Kuniyoshi for the exquisite tonalities of his still lifes — Grosz for the writhing lines of his tortured world. The point to remember, let me repeat, is that the compulsion must come, not from public demand, but from within the painter.

So far, we have discussed only the price range on "average" work. For the occasional painting that I like, and place in the "best" group, my own solution is to place this on sale at a considerably higher price than the highest in my average group. If the painting sells at this higher price, very good. If not, then I am willing to keep it with the anticipation that as my average sales price increases, it will become salable. And psychologically, it makes the prices of the pictures in the "average" group seem low if a few paintings in the collection are priced, comparatively, much higher.

As for the "fair" paintings, my solution is not to exhibit them, but to place them in a portfolio, priced nominally. In showing them, my agent explains that these are paintings that the artist felt dissatisfied with, for one reason or another, and that is why they are priced low.

One rule I have followed without exception is the maintenance of a price, once it is established. If you price a painting at $50 and it fails to sell for a long period, do not reduce its price. Withdraw it from the collection, if you like, or send it to another agent, but do not cut your own prices even in exceptional cases. You must make the public feel that once you place a price on a painting, that is the amount it will be sold for. Certain people will attempt to haggle, will offer a little less than your price, or will ask for a discount if they buy two paintings. Some agents are inclined to want to bargain on this basis, because they feel it will help them put over a sale that they might otherwise lose.

Such a method of selling, however, soon leads the public to distrust your prices. If you sell a painting for $40 that was priced at $50, everyone who hears of it (all the friends of the purchaser) will then feel that they would not be getting a fair bargain on one

of your paintings unless they too received a 20% discount from the marked price.

After three months of selling on the basis I have outlined, you should take stock of your situation and analyze your sales by getting the answers to these questions: How many paintings have been sold? In what price range? What was the average sales price? How much money have you made?

Perhaps all this seems foreign to the field of painting — and I suppose it is true that most artists have never studied their sales from the merchandising angle. That is just the point of this whole approach. *A painter must think as a painter in producing his work — but he must learn to think as a merchandiser in selling it.*

If you are selling your work more rapidly than you are producing it, you are in the fortunate position of being able to put your new paintings on sale at higher prices. But if you are not selling as rapidly as you produce — if your work is beginning to pile up — there are two solutions. Could your present agent sell more if prices were lower? Have many people been interested and failed to buy because of price? If by reducing prices 10% on new paintings you could increase sales 25%, then it would be wise to do so. If, however, you thus lower your average price and sales are not increased, it would obviously be a mistake. In this case the answer is to get an additional outlet for your work in another community, where it will not conflict with your present agent's activities.

If you live in Akron, it would be simple to select a second agent in Cleveland. If you live, let's say, in Waco, Texas, you could easily have agents in Dallas, Fort Worth and Austin. But do not spread your work too thin. Unless each of your agents has a representative group of your paintings, and is selling them steadily at a rate which makes handling them a worth-while effort, he will soon, quite naturally, lose interest in the arrangement.

After six months, you will be able to tell fairly well how your price schedule is working out, and how much income you can expect. Do not become discouraged if it is low. These things require a certain tenacity, and a willingness to experiment with prices. Even if your average income is no more than $200 a month for the first year — or even if it is less — do not give up.

You can't live on it? Lots of people live on less — people with families, people who bend over a noisy machine all day, or over a cluttered desk — without the deep satisfactions that come from painting as a reward, or the infinite horizon that a painter looks toward as a challenge.

If at this point you are thinking that this is not what you have in mind at all, not "important" enough, not the life of an artist as you visualized it, then examine it more closely. You are painting every day, all day — developing your talent as rapidly as possible. You are painting just as you please, with full opportunity to follow your own ideas, wherever they lead you. Your work is already hanging in half a hundred homes and offices, bringing whatever pleasure and inspiration you have been able to put into it to hundreds of people who are better for it. And you are making enough money to enable you to continue — to keep trying for the good work you hope is in you — perhaps to contribute something of lasting worth. And this is just the beginning. What more could you want?

VIII · The Questions You Will Face

THERE HAVE BEEN some objections to the pricing plan discussed in the last chapter. The most frequent criticism is that selling paintings at whatever price they will bring is "giving away your work." This criticism misses the entire point of the plan. I am not advocating the selling of paintings for a penny less than the most they will bring on the market. I am suggesting that it is *unrealistic and futile to try to sell them for* MORE *than they will bring*. And the only way to determine what they will bring is the method just described.

Almost every week someone who has my best interests at heart and who is certain he is right, tells me that I sell my work too cheaply. Sometimes it is a person who has bought one of my paintings, and he tells me that he would have paid more for it. The fact that such a thing does happen is not significant, nor does it prove that the prices are too low. Only the over-all pattern of sales as related to work produced decides that.

If my paintings are piling up on my dealer's hands, my prices are too high for my market. If, on the other hand, I have been painting steadily and find that one of my agents has only five paintings on hand, and another one has only two (which is the situation as I write this) then I know that my prices can be raised.

Hooray! But that is the only way I can tell. I cannot raise them because, in some friendly soul's opinion, they are too low. What he says is just a pleasant form of flattery.

Another serious objection is that such a plan requires that a painter turn out a tremendous volume of work — more work than it is possible for him to produce — more work than he can do well. One painter put it this way. "Suppose," he said, "that my average net income from a painting, after I have paid my dealer's commission, is $25. In order to make $5,000 a year, I would have to produce and sell 200 paintings. It's ridiculous."

Stated that way, it is ridiculous. But this figure of 200 salable works does not mean, obviously, that many major efforts. Suppose you are working on a large oil painting which requires a month or more of work. In the course of this work you make sketches, color notes, more or less finished studies, each of which has the characteristics of your thinking. Your large painting is going to be out of the financial reach of most people, but these sketches are not. They are more personal, more intimate, and quite possibly more interesting in some ways than your larger, more formal works.

Every sketch, every study, every drawing which seems to have meaning and substance is placed on sale after it has served its purpose to you. If you do twenty paintings in a year, and in doing each of them produce as a by-product ten sketches of various kinds, you have not 20 but 220 works for sale. Assuming that you receive an average of $100 net for each of your twenty large paintings, then your smaller works need only average $15 each to give you a net income of $5,000.

If you work in watercolor, and work steadily, the nature of the medium makes a large volume of work inevitable. And regardless of the medium you use, the fact that you are devoting your entire time to painting means that you will do far more work than a man who spends half his time teaching or in some other activity. And it means that eventually you will do better work, if you have it in you.

This matter of the number of paintings a man does brings up another point. Some painters seem impelled to produce large canvases — paintings of such size that there can be no possible place for them except on the walls of a museum, or a large public

building. This is an age of small homes with low ceilings and limited wall spaces — and of apartment living — and yet there are painters who spend their entire time producing one painting after another which is not just out of scale with today's homes, but, as can be shown by simple arithmetic, would not even go through most people's front doors.

No one can, or should, tell a man what kind of pictures he should paint, or how big they should be. But I think it would be wise for a man who is spending all his efforts on works of such tremendous size to ask himself, and possibly a good psychologist, why he is doing it.

It is true that Rubens painted large canvases, as did Rembrandt, and Botticelli, and many another painter. But it is pertinent to point out that each of these men painted these enormous pictures because he had a customer who wanted them. He did not do so arbitrarily, and in spite of the market for painting in his period. I have an idea that if King Philip had lived in a palace with nine foot ceilings, Velasquez would have painted pictures in scale with the walls that were available, and that they would have been, without question, as masterful and as moving as the ones he did paint to hang on the high walls of the Escorial. It is not possible to measure the significance of a painting in square inches, nor to judge its emotional impact in square feet.

If it is the artist's job to interpret life to his fellows to express his emotional responses to the world and share them with others, then it is part of that job to make his work available, both as to the price they can pay, and as to the size they can use. If a man can paint a good picture six feet by four feet, then he can paint one sixteen inches by twenty inches. More size does not mean more freedom. There is more light and air, more thought, more impact in one of Cézanne's still lifes, which measures twelve and one-half inches by fifteen and one-quarter inches, than in all the acres of canvas covered last year by a hundred painters.

My own belief is that paintings are for people, and belong in people's homes. A painting of such size that it may be hung on the wall of a living room has wider potential usefulness in the aesthetic sense than a painting so large that it is out of scale anywhere except on the walls of a museum. If you believe that paint-

ings are for people, then your work will grow more personal; you will be moved more and more to express yourself in paintings that they can have as part of their lives. And if paintings are not for people, what are they for?

Some painters have objected to the kind of prices I suggest by saying that many people refuse to buy pictures which are priced low because they think such pictures cannot be of any real value. There seems to be a large school of thought which feels that paintings priced at $25 and $50 and $75 will be considered second-rate, while prices of $300 and $500 and $1,500 will impress prospective buyers.

From the prices I see on the work shown at many exhibits, there must be many artists who feel that this is true. A very ordinary still life, by a man who has not sold three paintings in the last year, bears a price of $500. A watercolor with a certain spontaneous flair, done in a "happy-accident" technique which must have been completed in thirty minutes, is priced at $300. An abstract oil, of some charm, and done with considerable thoughtfulness (but not, after all, a Braque) is $2,000. A painting I would like to own for its design, and its subtle color pattern, is priced out of my reach at $150, although I later learn that it is the work of a young man who had never exhibited before, and who has never sold a painting. (As I write this, a year later, he still has not sold a painting, and he has taken a job in another line of endeavor.)

There are, without question, a few snobs and a few completely naive people who judge a painting by its price, but neither of these are the kind of people, I should think, that one could want as purchasers of his work.

I once sold a painting to a shrimp fisherman for a dollar down and fifty cents a week. He hung it over the stove in his one-room shack. I have sold a number of paintings to one of the Rockefellers, and have heard that he has one of them hanging in his living room. Which of these men gets the greater enjoyment from his painting I do not know, but both did me the honor, each from his own end of the economic scale, of wanting the painting regardless of its price.

If the prices on your work are intended to impress people, you can be pretty sure that some people will be impressed. Once

in a while, someone may be sufficiently impressed to buy one. But this will not happen often enough to enable you to make a living. And there is always the question as to whether it is not more desirable that a purchaser be impressed by the painting, rather than by its price.

There is no discussion in this book of prices on portraits, because it seems to me that portrait painting is a special field. The problem of the portrait painter is not primarily a problem of price, but the problem of pleasing the client and yet retaining his integrity as a painter.

It would be nice if a portrait painter could paint as he pleased, but it is seldom that he can. There are some good portraits done, and some fine painters who do portraits. But the endless bickering, the stupid criticism, the constant demand for compromise that are part of almost every commission, are things that drive most painters away from the field.

If you paint any other kind of picture, and someone says, "I don't like it," your obvious and simple reply is, "Okay, don't you buy it." If you paint a portrait and the sitter, or her husband, or her Aunt Hattie, or one of her neighbors finds some fault with it, you are in a hassle. And there is probably no surer or quicker way to go stark, raving mad than by painting portraits of the children of the well-to-do.

If a man develops a slick, photographic style, and if he has the knack of subtle flattery, both with his brush and with his tongue, and is a smooth man with a teacup, he can, very likely, make a lot of money painting portraits. Sounds pretty gruesome, doesn't it? Let's drop the subject.

If you like painting figures, there is a way to do it. Make portrait sketches on these terms: The decisions as to pose, handling, and degree of completion are to be entirely your own, with the subject merely acting as a model for your work. When the sketch, or the painting, is completed the subject decides whether or not he wants it. On some of these things you may spend only an hour's time. If the job proves interesting, you may spend much longer. If the model wants what you have done, he pays you, let's say, $25. If he doesn't want it, you keep it.

I started doing this when I first began painting, as a method of

getting models without cost. It grew, without effort or solicitation, to a point when quite often I had a whole list of people waiting for an opportunity to pose. Some of the sketches were failures, and some were fairly interesting pieces of work. I learned a lot doing them, and during the period that I followed this plan it provided a certain amount of income.

Later, for awhile, I painted some portraits, but we don't talk about that around our house. The dog remembers those days, though. I used to kick him off the front porch every day when I came home.

A problem that comes up about selling paintings at low prices is what to do about frames. When a picture is priced at $1,000, the frame, even if it is a rather expensive one, doesn't represent a large percentage of the cost, but when a painting is priced at $100, the frame makes quite a difference. The only answer is to sell all your work without frames.

Selling your work unframed has several advantages. First of all, the cost of framing is considerable; it is money which may be tied up for a long time, and is an investment on which you cannot expect to make any profit. The cost of the frame must be added to the selling price, and when your sales philosophy is to keep prices low, this added cost lessens your opportunity for a sale.

Oil paintings, however, are quite often greatly enhanced in appearance by the proper frame, and on your more important work this may make a frame worth what it costs. But it is very easy to get a lot of money tied up in frames, and such a thing can break you.

The problem can be avoided entirely by matting all your work, oils as well as watercolors. Make your mats for oil paintings out of $\frac{3}{16}''$ beaver board, which can be cut with a sharp knife, and paint the mats with rubber-base or casein paint in a color suitable for the painting, in the same way that you would finish a raw wood frame. Paint the mats on both sides and they won't curl. By using casein-base paint, a textured surface can be applied, and once this is dry other colors can be scumbled over it if you like. Do not do an elaborate job, however. These mats are not intended as permanent frames, and should not appear to be. They can be fastened to the paintings by strips of gummed linen tape glued diagonally

across each corner of the stretcher and to the mat, and reinforced with thumbtacks both in the mat and on the stretcher.

If this idea does not appeal to you, then do what so many painters of the modern school are doing. Simply nail a narrow wooden strip all around the stretcher, so that its edge extends a little above the face of the painting. This is inexpensive, quite suitable, and often very effective.

Some painters use canvases of sizes which fit the ready-made raw wood frames now available in art supply stores. If this matter of being bound by canvases of certain dimensions and certain proportions does not inhibit you, the use of ready-made frames is a fairly inexpensive solution. But beware that you do not let your ideas be limited by the sizes of frames available.

Watercolors, I believe, sell better without frames. One indication of this in my own experience happened when the Craft House of the Williamsburg Restoration began selling my watercolors. They selected six which they thought above average and had them beautifully framed. Twenty-seven matted paintings were sold before the first framed one was sold, and after forty-five matted pictures had been purchased, there still remained four of the framed ones, although the prices were about the same, except for the added cost of the frames.

I do not know why this is, although two possible reasons have occurred to me. One is that many people have very definite ideas about frames, and it quite often happens that a purchaser likes a painting very much, but does not like the way it is framed. The other reason is that some purchasers will stretch their budget to pay $50 for a watercolor unframed, with the idea of buying a frame later. The same painting, its price increased considerably by a frame, would be beyond their financial reach.

These people who must count their pennies before buying are the ones I have a special feeling about. A person who can sit down and write you a check is nice to have around, but a person who must pinch a little somewhere else, who must pay a little down and the rest when he can spare it — you can be certain that the painting he is buying means a great deal to him. He is paying your work the finest kind of compliment.

Which reminds me that people who buy paintings are invariably

honest. Many of my paintings are bought by people who find it necessary to pay on the installment plan. My dealer has no credit department. We don't ask the purchaser to sign anything. We have delivered paintings many a time to entire strangers who made a down payment of only a few dollars. *In the twenty-two years I have been painting, I have never had anyone buy a picture who failed to pay for it in full.* Since there are, I understand, some people who don't pay their bills, this indicates to me that if everyone liked paintings, everyone would become honest—a thought that has all kinds of implications about the value of painting to society.

What about teaching as a supplementary income? If it does not interfere with your full-time job as a painter (painting is a full-time job) then you may find it helpful, and you will probably learn a good deal. I am certain I have learned more from teaching than my students have learned from me.

Teaching can easily become burdensome, and eat into your time, and, since it takes a good deal out of you, can cut down on the energy you should save for your work. I taught for several years at the local museum, but only one night a week, and with classes limited to ten people. Even that can be tiring. Later I instructed an outdoor sketch class which met on Sunday mornings from nine to twelve. This interfered less with my work, and offered the students a greater variety of subject matter than the still lifes which must be used for a studio class. For the past several years, I have not taught at all, but have limited such activities to an occasional evening lecture and painting demonstration to any interested group. These are usually sponsored by art clubs with the purpose of making a profit from the sale of tickets. My fee is $50, for which I talk about watercolor technique; present a color movie which shows the painting of a watercolor, to which I add a running comment; and finally demonstrate my methods by actually painting a sketch and answering questions.

IX · Publicity

IN ORDER to make a living from your work, you need to have it known that you are a painter. If people know something about you, they are more apt to want to see what you are doing. When you have an exhibit, the public must be told about it if you are to attract as many visitors as possible. When you achieve an honor, it should be announced, because of the prestige it will bring your work. Publicity will not make you one whit better as a painter, but it will keep the public informed as to your ability and progress. And it is the public that buys your paintings.

The best way to reach the biggest audience with news about what you are doing is through the daily newspaper in your community. This is true in spite of the fact that art news is not worth much space, in the opinion of most newspaper men. If you win a purchase prize the same day that a drunken sailor wraps his car around a telephone pole, he will be on the first local news page, with a three-column cut of the wreckage, and you will be on an inside back page, with two inches of type, between the report of a garden club meeting and a supermarket advertisement.

This may irritate you. But you got the space that the city editor decided your story was worth. And he knows his business. Whenever the readers of his paper become as interested in reading art

news as they are in accidents, or sports, you will find that every paper will have a two- or three-page art section, every day. If you have not looked at publicity from the standpoint of the newspaper man, you may have an unfriendly attitude toward newspapers, and toward reporters. But you would be wrong.

What goes into a newspaper is dictated by public interest, reduced to the lowest common denominator; not by reporters. In fact, newspaper reporters as a class are about as nice as anybody you will ever know. They are intelligent. They are curious and interested in everything on earth. They are not, on the other hand, easily impressed, nor are they easily excited. They have talked to the lions of many an hour, to the pompous and the humble, and they know that people are not necessarily great because they are famous.

Reporters have a well-developed loathing for the self-important. They are inclined to skepticism, and are no respecters of persons. If they believe in you, they will cooperate in every way they can. If they decide you are a phony, they will let you severely alone.

Some painters, miffed at the lack of respect given to them by newspapers, have been guilty of arrogance toward reporters. Some are uncooperative, because they think reporters ask prying questions, or do not show proper understanding of the painting they do. These attitudes are inexcusable. Any reporter that I have ever met, if treated pleasantly and fairly, will be as cooperative as his job will allow him to be. His job is to get the news. If he asks you a question about something you don't want publicized, say so and tell him why. Reporters are like you and me, they don't like arrogance, and they are irritated at being patronized.

More than most people, reporters respect honesty and frankness. There is no better way to be sure of fair treatment by the newspapers than by being yourself—saying what you think, whether or not it is a popular opinion, and answering questions simply and fully.

Above all, don't bother the papers unless you have a story. If you ask them for space on something that is not of general interest, they will begin to duck when they see you coming. If they hear from you only when what you have to tell them is worth a story, they will welcome you, because they *want* news. That's the way they make their living.

How do you tell when you have a story? You are a newspaper reader. You know that its pages are made up of what has happened, what is going to happen, and of the opinions of people on these two classes of events. If it has happened, it must be important enough ("Twenty Hurt in Bus Accident" or "Local Artist Gets Commission for Mural") or unusual enough ("Bird Builds Nest in Bank Entrance" or "Preoccupied Painter Marooned by Rising Tide") to merit public interest. If it is going to happen, it must be able to answer the question "Who cares?" with a significantly large segment of the public who do care.

If you don't know the man (or woman) who handles art news for your paper, call the paper and find out who he is. Then when you have anything you think is worth a story, call him and ask him if he has time to see you, and when it will be convenient. When you go to see him, take along whatever you have that he might be able to use *on this particular story only*. Don't write anything. Reporters do their own writing.

You will be surprised how pleasant a fellow he is, but you may be surprised, too, at the casual attitude he has toward what you have to say. Reporters are seldom openly enthusiastic. Don't give him a long, detailed discussion. Give him the bare facts. If he is interested, he will ask questions. If he isn't, he will be even less interested after you bend his ear.

When the story appears, don't be critical of what you got. If any facts are incorrect, call and say so. If not, be thankful that the story ran. The editor gave it what he thought it was worth, and it's his paper. If you like the story, call or write a note and thank the reporter — he is like you and me in that respect, too; he likes to be told he did a good job.

If the reporter becomes interested in you and the work you are doing, he may want to do a "feature story" on you. These are predicated upon human interest rather than topical interest, and are usually prepared well in advance, and published in Sunday editions. Such a story usually includes the use of several pictures, and this makes a feature story especially effective publicity for a painter. It is the kind of thing you can't ask for — they have to ask you. But if you are doing a worth-while job as a painter, they will ask you, sooner or later.

Timing can be important in giving stories to newspapers. Some days they have what they call a "tight" paper, with lots of advertising, and on those days news stories of slight importance get left out, or pared down to a few lines. Other days there is lots of room, and a story of only the vaguest interest will be given half a column. You can't decide when things will happen to you, but when there is a choice as to the day you release the story, remember that on most papers Mondays and Saturdays are the easiest days to find room for it, Tuesday is a little harder, and Wednesdays, Thursdays and Fridays get increasingly tough.

Sunday papers are a special matter. It is difficult to get art news into the crowded general news sections, unless the item is of considerable importance. But most Sunday papers have a page or two devoted to art news, and it is relatively easy to get something on these pages. There is this to remember, however; the section of a Sunday paper which contains art news is generally printed days ahead, so the dead line for anything in that section may well be the preceding Tuesday, or Wednesday at the latest. Find out when it is on your paper.

In order to simplify the job, and to keep from spending unnecessary time on publicity, you need to do several things. You should have a biographical data sheet. This gives your place of birth, your age, background, education, work you have done, commissions you have executed, exhibits you have held, honors you have won — everything of pertinence about your career as an artist.

This sheet should be kept simple. It should be entirely factual. It is useful to give anyone who wants information about your career. It is helpful to reporters as background information, or to persons who are to introduce you when you speak in public, since these people, if you give them the information verbally, have a genius for scrambling the facts.

I type about five copies of my data sheet at one time on onion skin paper, and use these until they are all gone. By that time something usually needs to be added, and I type another set which includes these new items. In this way, the information is always up-to-date, and it never becomes necessary to throw away a whole pile of sheets because they do not include recent data.

Another thing you may want to have on hand is a supply of photographs of your work, and of yourself. Don't go out and buy these unless you have to for a specific purpose. Wait until the newspaper wants a photograph of some of your paintings or of you, and then buy some prints from the fellow who takes the pictures. He'll be glad, usually, to sell you some for a lot less than you'd pay a commercial photographer, and you'll find that he takes good photographs.

You should have a letterhead to use in writing to people on matters concerning your work. This should be quite simple in design, and needs only your name and address. I like what is called a "Monarch" size sheet, which is $7\frac{3}{4}''$ x $10\frac{1}{2}''$, a little smaller than the usual $8\frac{1}{2}''$ x 11". This enables you to use the same sheet as a statement, by cutting off the bottom.

Finally, you should keep a scrapbook. The only practical kind is the big one, 19" x $23\frac{1}{2}''$, that will take an entire newspaper page without folding. Keep in your scrapbook every piece of printed material pertinent to your career. This includes news clippings, catalogs of exhibits in which your work appeared, magazines reproducing your work, and memorabilia of every kind about your life as a painter. Don't show this to anyone unless you have a specific reason for doing so, and then show him only those things apropos to the situation. A book of this kind can be of value only very occasionally, but once in a while someone will want a detailed story of your history as a painter, and then a carefully kept scrapbook is the best and most impersonal method for giving him the information.

You will not always agree with the things said about you in print. The things said about your work may hurt even worse. Every person in the fine arts faces this problem. No matter how mad you get, remember that hardly ever is a critic malicious, and that he is never, in his own eyes, unfair. He is paid to state his opinions. There is always the possibility that he is wrong — critics have been wrong in judging painting about as often as they have been right. But there is little chance you can get him to change his opinion. One of the most difficult things to do is accept adverse criticism silently, and not let it embitter you. You will have to learn to do it.

X · *Your Own One-man Show*

ONCE A YEAR you should have an exhibit of your new work in your own community. This serves several purposes. Although you have been painting and selling paintings throughout the year, an exhibit focuses attention on your work—both the attention of those who already know about it, and of others who do not. The fact that you are having an exhibit enables you to get publicity from newspapers, and quite possibly from radio and television stations. Most important, it enables you to sell a volume of work in a short time, and thus augment your income.

From the agent's standpoint, another valuable thing is the opportunity to develop a list of prospective purchasers, with notations beside each name as to the painting in which that person expressed interest. In my most recent exhibit, thirty-nine paintings were sold, but in addition to this my agent developed a list of some sixty persons who would have bought paintings had these paintings not already been sold when they visited the exhibit. My agent knows, for example, that if I deliver to her during the coming year a painting of a night street scene, she has a likely purchaser in Mr. A——, who liked the painting "Street at Dusk." And Mr. B—— liked a shipping scene, and wants to see any new ones. And so on.

I do not see this list, because I want to be sure that I cannot be influenced by it in selecting new subject matter. But my agent finds, so he tells me, that he uses it effectively, and has gradually over a period of years built up a considerable "waiting list" of prospective purchasers, most of whom sooner or later become owners of paintings.

We have our exhibit near the end of November because that time of year finds people in a buying mood. Each year a certain number of pictures are bought as Christmas presents. And we always have the show at about the same time each year because many people have gotten, so they say, to look forward to it.

If your agent operates a store—and, as I have suggested, a bookstore makes a good outlet for paintings—then perhaps you can have an exhibit there. But most bookstores are crowded, and unless sufficient room can be had to show the paintings effectively, and allow floor space for visitors, do not try it. Nothing hurts an exhibit so much as trying to fit it into scattered wall spaces, with other things also displayed in the same area.

In a store where there are no large, unbroken wall spaces, one solution is to cover the walls with gray display paper, which comes in rolls 9 feet wide and 36 feet long and costs about $10 a roll. It can be tacked up quickly, creates large surfaces of a neutral color, and is remarkably effective in pulling a room together and making it seem larger—and surprisingly, the paper does not have the improvised appearance one might expect.

Do not have your exhibit in an art gallery, unless no other place is available. Each year we have been invited to exhibit in local art galleries, and my first one-man exhibit in Norfolk was held at the Museum. It was a mistake. Art galleries and museums are almost never centrally located, and to be well-attended an exhibit needs a central location in the shopping district with lots of pedestrian traffic. Plus this, there is a serious psychological handicap when you exhibit in a museum or gallery. People in the mass are deterred from visiting these places. They think of them as places where a special group congregates—a group to which they do not belong. They have been made to feel like intruders, and they stay away.

Those people who do habitually attend openings at galleries and museums, when told of this, say that it is ridiculous. It is a fact,

however. My annual exhibits in Norfolk always open at three o'clock on a Sunday afternoon. For the last several years, the crowd has begun to gather in front of the building soon after two o'clock, and by three o'clock there is a throng in a sort of unorganized line down the street. Twenty minutes after the opening of my most recent show, my agent asked me to go outside and welcome the people still standing in line who had not yet gotten into the building. By contrast, when my paintings from the permanent collection of the Norfolk Museum were exhibited in the museum's largest gallery a few years ago—some of the best work I ever did—a handful of people came: the same handful who drink tea at every museum opening.

The crowds who come to our openings do so, I think, for two reasons. First, they feel welcome, and second, they know that if they see a painting they want, they will be able to afford it, and if they want to, they can pay $5 down and the balance over whatever period they choose.

Strange and flattering things happen because of this feeling people have. One year I went to the gallery at noon on opening day to deliver a painting I had finished that morning. A young woman was sitting on a camp stool in front of the door. She seemed to be waiting for something, and yet it seemed wildly unlikely that she was there to be first in line for a show that wouldn't open for three more hours. When I came out, I asked her. "My husband and I are determined to get the picture we want this year," she said. "He's coming by in a few minutes to spell me, so I can get some lunch."

I thanked her, and went home feeling the mixed emotions of humility and elation which such a thing can arouse. My paintings are not that good, and I know it. They are competent, and done with serious intent, but the kind of following my work has developed must come rather from the feeling many people have that these paintings were done for them, as indeed they were.

To illustrate how you might go about an exhibit, here is what we did at one of my early Norfolk shows. About a month before the date we had decided upon, we began to look for a vacant store which must meet three basic requirements: (1) It must be on the ground floor. (2) It must be in a reasonably central location as related to stores and theatres. (3) It must have large,

unbroken wall surfaces and good interior lighting.

In addition to these requisites we wanted, if possible, a display window, heat, and near-by parking facilities. And the building would have to be available for temporary rental at a nominal fee.

We found five suitable places. Inquiry developed that three of them were available. We decided upon a building with floor space about 20′ x 60′, gray papered walls, a display window, and a gas heater already installed. It was one block from the city's main street, and the rent was to be thirty-five dollars for one week's use. We agreed to pay the gas and electricity.

The room had one major defect. The rear wall was broken up by two doors and a built-in bookshelf. After considerable searching, we found a black curtain at the Goodwill Industries which covered this wall completely, and was wide enough to allow for some pleating. This transformed the ugly rear wall into the focal point of the room.

Across the front of the store was a sign, two feet high and twelve feet long, which had advertised the most recent occupant. I bought four yards of white oilcloth and painted on it, "Fifth Annual Exhibit, Paintings by Kenneth Harris," and the day before the exhibit opened I borrowed a stepladder and tacked this oil-cloth over the old sign. The lettering I had used was simple and dignified but you could still see the sign two blocks away.

A week before the exhibit was to open I painted a 30″ x 40″ display card which stated that the exhibit would "open here" on Sunday, November 29th at 3 p.m., and gave the daily hours, 9:00 a.m. to 9:00 p.m. This I placed inside the glass of the display window. I also hand-lettered about a dozen 9″ x 12″ cards, giving the facts about the exhibit, and its location. These my agent placed in various locations — on the Museum bulletin board — in the Library— in the windows of art supply stores—and in other places where we felt a number of interested people would see them.

More than a week before the exhibit was to open, I took about half of the paintings and went to see the Sunday editor of the morning newspaper. I went early, because the feature sections of the Sunday paper are printed days ahead. I gave the man who does the art news the facts about the show, and answered his

questions as to my recent activities. He looked over the paintings and selected two for use in the paper, called in a photographer, had them shot, and gave them back to me.

Then I went to one of the local television stations. I had appeared on some programs previously, and they knew about my work. I told the man in charge of public service programs about the show, and showed him the paintings. He offered me a five minute spot on a morning variety program, scheduled for the day after the exhibit opened, during which I would show some of the paintings and be interviewed by the master of ceremonies.

On the Thursday before the opening day, my agent called the afternoon paper, told them we would be hanging the exhibit on Friday afternoon, and asked if they would like a picture of the paintings being hung, and an interview, for Saturday's paper. A photographer and a reporter showed up Friday while we were working on the show, took pictures and asked questions.

About two weeks before the exhibit, as soon as we had decided on the location, I hand-lettered an announcement to be printed by offset. This avoids typesetting costs and the delays of proofreading. While the printing was being done, my agent addressed and stamped the envelopes, which I had gotten in advance.

The mailing list was a carefully selected one. It consisted of people who had previously bought paintings, people who had attended previous exhibits, members of organizations before which I had talked, people active in local cultural circles, and a general list of doctors, lawyers, architects, engineers, college professors, social workers and people in other cultural and scientific fields, because we have found these groups are interested in painting. The list totalled 500.

As she inserted the announcements, my agent wrote personal notes of invitation or comment in a marginal space provided by the design to people she knew who were on the list. All the announcements, including those which contained no written message, were sent by first-class mail, for two reasons. First, we felt the recipient would give the announcement more attention because it was hand-addressed first-class mail, and second, we knew that first-class mail is delivered promptly, while third-class is often delayed, and we wanted to be certain the announcements would

be received on the Wednesday preceding the exhibit. Direct mail experts have proved that mail received on Wednesday or Thursday gets more attention than that received either early or late in the week. One might as well take advantage of facts.

That was our publicity campaign. For a week before the exhibit, every person who passed the location saw a sign in the window announcing what was to happen, and when. And all over town cards were reminding others of where and when the show was to begin. On Wednesday, 500 especially good prospects received an invitation to attend, many with hand-written notes appended. On Saturday, on the first local news page of the afternoon paper, there was a three-colum 8″ cut of my agent and me hanging paintings, together with a two-column interview. In the Sunday morning paper there were reproductions of two of the paintings on the art news page, with a story which gave the location and opening time of the exhibit. And for anyone who decided to attend, and was looking for the building, there was a sign in front that could be seen a block away. And then, as a follow-up, there was the television interview Monday morning, with the announcement that the exhibit would be open all that week.

The cost of this publicity program was $50. The announcements were $30, the stamps were $15 and the other items totalled about $5. It was more publicity than is usual for an exhibit in my town, and was criticized from two angles. One person questioned why the newspapers and the television station gave the exhibit such a big break. I am quoting the answer because it is significant. "The fellow knows what is possible, and he cooperates."

The other criticism was that so much publicity cheapened the exhibit. This, it seems to me, is hog wash. The paintings were not affected one way or another because so many people heard that they were being shown and came to see them. I cannot see that there is anything either dignified or undignified about being a painter. Too many exhibits — some of them by good painters — are not attended by the general public because the only people who feel free to attend are the select few who receive formal invitations. There is no influence so cheapening as snobbery.

The morning of the exhibit I brought my record-player down, together with some chairs and a couple of coffee tables. (My

living room was a little bare that week.) My agent brought a small desk and some flowers.

At noon we were ready. A small sign reading "Open—Come In" was ready to be placed in the window at 3:00 p.m. On the desk was another small easel card saying "Paintings may be purchased on the installment plan." The pictures were hung, and in the corner of each one was a 2" x 4" card, giving its title and price. The floor was waxed; the windows were washed; the flowers were in their vases; the music of Brahms was coming from behind the curtain; the red stars were waiting in a box on the desk. And as always, I was scared to death.

The exhibit was supposed to open at 3:00 p.m. but by 1:30 people started coming. By 3:30 the crowd was dense and the place remained crowded until after 6. That first day we sold 25 paintings for $1,265.

During the week people continued to come. We sold 39 paintings for $1,655. After deducting our expenses, which totalled $109, we had a net income of $1,546 for the week's show. This is unusual in a town of 200,000. I am told it would be unusual in a much larger city. But it need not be.

The things we did any painter can do. We found a good location, carried out a careful publicity plan, and made the exhibit as attractive and comfortable as we could without spending any money. And we exhibited 40 new watercolors at an average price of $43, with only one painting priced over $100 and a great many at $25 and $30 and $40.

Since then we have had many exhibits. The prices are higher now, based on the theories given in Chaper VII, but we are careful to keep the price range within the reach of most of the people who come. Nowadays we place a printed card, perforated and folded, in the corner of each painting. It reads as follows: "To reserve painting REMOVE THIS TAG. In fairness to everyone we must insist that no tag once removed can be replaced." Below this is the name of the painting and its price. When the tag is torn off along the dotted line at the top, it reveals the other fold beneath, on which is printed a red star. This card remains on the painting. On the back of the part torn off by the purchaser is a form which, when filled out, gives the name of the purchaser,

his address, his phone number, the payment made, and the balance due. He brings this card to a sales person, the card is filled out, and the sale is complete.

Some people have considered this method of selling peculiar— or outlandish—and some have found it outrageous. It came about by necessity. We found ourselves, a sales force of three, in a room with a couple hundred people who, when they found a picture they wanted, stood before it with one hand on the mat, fending off other prospective purchasers and hollering for someone to wait on them. Once in a while, two women used to arrive at a decision at the same moment; and if you want a real problem, try to judge which of two ladies actually grabbed a corner of the mat first, and which one first began to wave and say, "Yoo-Hoo!" They were not only miffed at each other; both of them were mad at us. All this was just plain embarrassing, and incredibly confusing, until we hit upon the self-service method—the tag with the perforated fold that can be torn off.

I will readily admit that those annual shows did not offer the purchaser a proper way to buy a painting. There wasn't time to consider properly what should be a serious, thoughtful decision. For that reason, I no longer have annual exhibits. We now sell all work as I produce it, throughout the year, which allows prospective buyers to see new paintings from week to week, with time for deliberation.

I must admit, however, that to stand in the back of the gallery in the old days, to see the doors open (with the door-opener, as the newspaper said one year, "nimbly jumping aside"), and then to hear the tags come off, "rip, rip, rip" was a satisfying experience. To an artist not yet established, the value of an annual exhibit, both for sales and for publicity, is fundamentally important.

Will the kind of exhibit I have described work in any city? I used to wonder about that, thinking that perhaps Norfolk was unique, or that the reputation I had developed locally was responsible for the results, rather than the methods we used. Three years ago we found the answer to that question. I had an exhibit in Richmond, Virginia, where I was known by very few people. We held the exhibit in a store building which was not in the central business area. The publicity, the invitations, the promotion were

the same as always, and as carefully planned. The morning paper ran a feature story about my work in Richmond, the afternoon paper ran a reproduction of a painting from the show on its editorial page each day for a week, and I was interviewed on the "good music" radio station. And sure enough, when Sunday afternoon came, there was a crowd waiting at the front door, and the tags ripped off almost as merrily as they ever had in my own home town.

There are certain things we have learned from our exhibits. Music is helpful both because it adds a pleasant atmosphere, and because when only a few people are present it enables them to talk to one another in a privacy provided by the sound of the music. Tea or cocktails—any kind of refreshments—are unnecessary and a lot of trouble, plus the fact that they tend to make a social event out of the exhibit. An exhibit is pictures hanging and people looking at them. Refreshments get in the way. Those who come to art shows to drink tea and converse with their friends should go somewhere else to do it, and get out of the way of people who come to look at paintings.

We have found that a catalog of the exhibit is an unnecessary expense. It is simpler and more effective to put the title and the price of each painting on a small card, and clip the card to a corner of the mat or frame. This eliminates the usual maddening process of finding the number on a picture, then looking for that number in the catalog to determine the title, and then following a dotted line, or an imaginary one, across the page to arrive at the price. Some people find our direct method of pricing pictures shocking; they say it is undignified. For those who prefer to starve to death in a dignified manner, I recommend an elaborate and expensive catalog.

Evening hours have proved very valuable. Men who see the show at lunch time and like a painting come back in the evening and bring their wives to approve the choice. Women who come in during the day tell their husbands about the show and bring them in that night. And many people whose work does not allow them to come during the day must come in the evening or not at all.

The story of how we held this exhibit is intended only as a general guide. In another city, under different circumstances, there

would be different problems with other solutions. But these basic facts remain; your exhibit should be in a place where as many people as possible can see it easily; you should tell as many people as possible about it; and you should put prices on your pictures that will enable almost anyone to buy the one he wants.

XI · *The Artist and the New York Gallery*

YOU CAN HAVE a one-man exhibit in a New York gallery whenever
you want one. There are several galleries that will hang your
paintings for two or three weeks, advertise the event in magazines
and newspapers, print a catalog, and open the exhibit with a cock-
tail party, if you will pay for all these items, plus a rental fee for
the use of the gallery. This will cost you $500, or more, or less,
depending upon the gallery, the amount of advertising done, and
the kind of catalog you have.

In the agreement, it may be stated that this sum of money you
are putting up is a guarantee, to be charged off against commis-
sions on sales made at the exhibit. But it is well to remember that
most of the one-man shows by painters who have not previously
exhibited in New York do not result in many — or any — sales.

The reviews of your show will probably not be unkind. New
York art critics have a gentlemanly custom of not shooting too
sharply at a painter until he is big enough to make a fair target.
In writing about most newcomers, they say nothing very politely
for about two hundred words.

So if you can afford $500, or thereabouts, for the privilege of
seeing your work hung in a New York gallery, plus a half-dozen
noncommittal clippings for your scrapbook, it is easily possible.

But it is a heavy expense, and since it is a thing anyone can do, it reflects no credit upon your work, or upon your good judgment. It has nothing to do with making a living as a painter.

Even so, a one-man show in a New York gallery is widely regarded as a real milestone in a painter's progress. It may be. That depends upon the gallery, and upon the circumstances surrounding your exhibit.

There are, you will find, all kinds of art dealers. There are men whose whole lives have been devoted to providing opportunity for artists whose work they believe in. If they believe in your work, they will do anything for you. It is these men, and the galleries they operate, that have done so much to keep New York galleries a moving force in promoting what is good, and what is new, in American art.

There are other dealers who are not to the same degree dedicated to painting and painters, but who are honest business men, seriously interested in doing a good job. They will try to sell your work, if they think it is salable.

There have been, from time to time, a few dealers who were not interested in painting in any constructive manner. An encounter with one of them can be a very disillusioning experience.

Galleries which take their obligations to the artist and to the public seriously will not offer a painter a one-man show unless they decide that his work merits their sponsorship. But unless they are fairly certain that you are going to be a sensation, they will still want a guarantee. If one of these established galleries offers you such a show, you may consider it a distinct compliment — but you may find, too, that it will cost you even more than $500.

If you should be offered an exhibit by *any* gallery, be certain that every detail of the arrangement is understood and that a written agreement is made, stating explicitly what you are to pay for, and what the gallery is to pay for. There have been many cases where this was not done, with resulting disagreement and unhappiness, because the artist took for granted that the gallery would meet certain expenses, and the gallery assumed that the artist knew he was to pay for them. Even when (as in most cases) the gallery and the artist are both perfectly honest and sincere in their positions, such misunderstandings can be serious, not only in

themselves, but because they jeopardize a relationship, at its very beginning, which might otherwise grow into a profitable and constructive thing for both parties.

So if you are offered a one-man show, be sure you understand what it will cost you, and be sure the agreement is explicit, and in writing. When you have this information before you, it is easier to judge the wisdom of going ahead. If a dealer believes in your work enough to want to show it on his walls, then he should be willing to share some of the risks by investing in the venture. If he is unwilling to do this, it is a pretty good sign that he does not expect the show to make any money.

Another point to be considered is how much guarantee you are required to pay in advance, and whether or not, if commissions do not amount to enough to cover the balance, the gallery will agree to take a certain number of paintings (at sales price less commission) in lieu of further cash payment. If they are willing to pay part of the expense of the exhibit, and if they are willing to accept one or more of your paintings at a net figure as part or full payment on the balance, you can be sure they expect your work to sell, and that they think the exhibit has a good chance to be successful.

If they are not willing to do either of these things, they obviously have no strong convictions about their ability to sell your paintings, and you should consider seriously whether the publicity and opportunity for profit is apt to be worth what it is going to cost you.

Unless the proprietors of some gallery are so convinced of your ability that they are willing to share the risk of an exhibit on some sort of equitable basis, it is my own belief that a one-man show in New York is a meaningless gesture. To an unknown painter, who must pay all the costs, with small chance of gaining either prestige or profit, it is apt to be a fruitless and expensive experiment.

There are advantages in having your work handled by a New York dealer, although these advantages are not always as great as might be supposed. Having a New York dealer may help your prestige, and it will mean occasional sales. But unless you are the exception, the sales made by a New York gallery will not support you. This is indicated by the fact that some of today's best-known

painters, listed as "stars" by prominent galleries, are unable to live from sales made by these galleries.

One reason for this is that these galleries reach so few people. Sometime, if you have the opportunity, sit in a 57th Street gallery for an hour or two, and count the visitors. On an afternoon not long ago I wandered around one of the most celebrated galleries in New York for an hour and forty minutes. Seven people came in. One was, from his conversation, a friend of the exhibiting artist. Two were obviously art students. That left four people who might conceivably have been prospective purchasers. Two of these were dowagers who stayed five minutes and discussed breeds of dogs. The other two, a man and a woman, seemed genuinely interested in the paintings — they studied several quite intently.

Even supposing that I was there on an exceedingly dull day, and that twice as many people usually came in, I estimated that in the two-week period during which most shows hang, about 400, or 500, or maybe even 800 people would come in, and that not all of these, by a tremendously wide margin, would be prospective purchasers.

The size of these galleries is evidence that they do not attract many people. Because of the high rental rates in the area where most of them are located, they must use limited space, or be ruined by fixed charges. Many galleries with illustrious names, representing some of the best, and best-known, painters in the country, have exhibit rooms not much larger than a two-car garage. If fifty people tried to come in at once, somebody would suffocate.

This may be considered carping criticism and unfair, since these galleries do not intend to direct their efforts toward the mass market. And it is true, on the other hand, that many of them do attract important collectors, and that their proprietors know and cultivate wealthy persons who are buyers of art. It is said that their important sales are made by these methods, and cannot be gauged by counting the few persons who wander in. And it is said, and is no doubt true, that the 57th Street gallery offers the one best method for reaching those people who are purchasers of significant American painting.

Sales to this restricted group are often for considerable sums. On these sales the gallery makes a commission. When the gallery

exhibits work which does not sell, it charges the unsuccessful painter a rental fee. The total income, from commissions *and rentals*, enables the gallery to stay in business and sometimes make a profit. It does not enable many artists to do so.

This is not intended as an attack on the New York galleries whose magic names make them the Mecca for so many painters, nor on galleries of the same type in other cities. Most of these galleries are run by admirable people, whose efforts on behalf of American painters are tremendous. They are people to whom painters owe a debt of gratitude. But the stubborn fact remains that even the efforts of all of them do not result in enough sales to enable more than a very few painters to make a living.

The trouble is, and it is a basic fault, that these galleries predicate their efforts upon the idea that the market for painting is a narrowly limited market. This market existed once but, as shown in Chapter II, it does not exist any longer. The money available for the purchase of paintings was once in the hands of a small homogenous group, and the established galleries served that group — *were developed to serve them.*

The market, in terms of money available, is now spread out to include nearly thirty million families, and although there is more money than ever, it is spread thin. The established galleries are still aimed at the restricted market which has nearly disappeared. They do not have the location, the facilities, nor the psychological attitude to reach the mass market which has replaced it.

Most painters feel that, while something is wrong, it is not the gallery system which is at fault, but failure on the part of the public to respond to painting. They know that unless they are talented enough, or lucky enough, to find a place among the very few painters whose work becomes sought after in the narrow market of the established galleries, they must resign themselves to making a living by some other means.

Neither the painters nor the galleries have realized that there *is* an untouched market, and that the mass nature of this market brings new problems, and requires new methods of approach. Who can say that this new group of possible purchasers will not respond to painting, until the effort has been made to put painting before them, and within their reach?

This new and wider market has disadvantages. Some of them have been mentioned. Most of these people are not now actively interested in painting. Individually they have little to spend. No facilities exist, in any planned way, for putting paintings before them for purchase.

But this market also has advantages. The very fact that it is so broad means that it is potentially a market for work of many kinds. And although none of these people can spend a large sum of money, each one can easily spend a small sum. *And, together, they can spend more money than has ever been spent for painting anywhere, at any time.*

To the objection that their taste is undeveloped, the obvious answer is that as they become interested, as they buy, as they live with paintings, their taste will develop. It is by these very methods that taste is always developed.

And which is better for painters, and for the development of painting as an art — a narrow, disappearing market of developed taste, which necessitates painters doing other work in order to live; or a broad and increasingly broader market of undeveloped but awakening taste which can support thousands of painters, and can enable them to develop their talent on a full-time basis?

Remember, there is no argument here that any painter should change his attitude toward his work, or paint for any market. The argument is that, once the pictures are painted, he should place them before the existing market, and sell them at prices which this new market can and will support. And the fact is that art galleries in New York, or anywhere else, do not reach that market as they are now operated.

As time passes, these galleries will revise their policies, and will direct their attention to meeting this new economic situation. They will have to do it to survive. There have already been some gestures in this direction, and there will be more. But today's painter cannot wait for this metamorphosis to be complete, and since there are other methods of reaching his market, he need not wait.

If the New York galleries are thought of, not primarily as a source of income, which they cannot be for many painters, but as if they were a group of honorary societies which recognize

superior ability, and bring it to the notice of critics and con-noisseurs, then they assume their proper place in the painter's scheme of things. Judged on that basis, they do a good job, and serve an eminently worth-while purpose. That is all they can be expected to do; their limited field of operation prevents them from doing more.

New York galleries are anxious to find new and promising talent. If you think your work may merit their interest, then go to see them, and show them what you have done. You will find them gracious and understanding people. They give their time and attention to many an unknown painter even though they do not expect to find undiscovered genius very often among the many hopeful painters who solicit their interest. They watch the annual exhibits and most of the regional shows. When a new talent appears, they are pretty sure to know about it. And when your work reaches a point where it deserves the notice of a big gallery, they are, more often than not, aware of it.

However, if it is New York representation you want, it can't hurt to try. If you are in New York, telephone the gallery and explain that you want to show them your work and ask for an appointment. Some galleries set aside certain hours one day each week for these interviews — and if that is the case, they will tell you so.

If you are from outside of New York, select from the listings in an art magazine some galleries that might be interested in the type of thing you do. If you are familiar with the work of artists who exhibit at the various galleries, this will give clues as to the kind of work that is characteristic of those galleries. Write and ask for an appointment and state what days you expect to be in New York, so that all your appointments may be grouped within these days.

After you have the appointments, it is merely a matter of carry-ing a portfolio around until you find someone who likes your work. It can get discouraging. Almost everyone will be cordial and considerate, but these people have seen a lot of paintings and you need not be surprised if they are generally noncommittal.

A few words of advice: Do not talk about your work. Just show it. Since you are attempting to interest these people in what you

do, it is obvious that what you are showing them is the best you can do. It must stand on its own feet.

One of four things will happen. First, you may not find anyone who is sufficiently interested to offer you any tangible help. They may say (and often do) that you are a year or two away from being ready; or they may say that their schedule is too full to make room; or they may suggest another gallery. All of these comments mean the same thing, of course. They mean "no."

Do not let it get you down. If it makes you mad, that's all right, because then you will keep trying—and that is what you must do. If you go away from the last of your interviews determined that you will fight it out on the same line if it takes ten years, and if you then go back and get to your work, you haven't lost anything.

The second thing that may happen is that you will find a gallery which, while it will not offer you a permanent dealer-artist arrangement, will agree to give you a one-man show. This kind of offer was discussed earlier in the chapter, but it might bear repetition to say that you should get a clear statement of the financial arrangement before going ahead with any such agreement. If you should decide that such a show is what you want, see that the contract states specifically what you are to pay, and says specifically that there will be no charges other than those covered by the contract.

The third possibility is that some gallery will decide that, while your work is not of such a nature as to merit a one-man exhibit, or an artist-dealer contract, it has enough merit and *salability* so that they will be willing to keep some of it and sell it for you. This, of course, is a desirable thing. They will not offer you such an arrangement unless they feel your work will sell, and while you cannot expect that they will put the same effort behind it that they do the work of their regular group of artists, you have nothing to lose, and everything to gain. Quite often, if your work meets a ready response from the gallery's customers, such an arrangement may lead, in time, to the offer of a contract, and an exhibit on a favorable basis.

The fourth thing that may happen is that you will be offered an artist-dealer contract—an invitation to become a member of the

gallery's group of member artists. This does not happen very often. It happens so seldom, in fact, that if it happens to you, you can be fairly certain they see something quite remarkable in your work.

A standard form of artist-dealer contract has been developed by Artists Equity Association—an organization operated by artists with the sole purpose of helping artists get a fair shake. This contract, which is the result of exhaustive study, and has been recognized as fair and equitable by artists and by many dealers, is reproduced in the Appendix by the kind permission of Artists Equity, accompanied by thorough explanatory notes which will help you understand each section.

Even if you are successful in getting a New York agent—even if you are given a one-man exhibit in which this agent shares the risk—remember that what you have gained is prestige, and not financial success. The prestige is valuable and heartening, but the problem of making a living still remains. The 57th Street galleries have not solved that problem for very many painters—the chances are that they will not solve it for you.

As long as you are a painter, you will be faced with the fact that the painter's audience today is a new one, that the greater part of that audience cannot be reached by today's galleries, because they are using yesterday's methods. If you are to succeed as a painter, you will have to have enough income to live on, and to get that income, you will have to make your work available to the great new audience that these galleries do not reach, and you will probably have to do that yourself.

XII · *Entering Open Exhibits*

SUPPOSE THE PEOPLE who write novels or poetry were asked to bind their manuscripts in attractive form at their own expense, and mail them to public libraries, where they were to be put on public display, so that anyone interested could come in and read them free; and suppose the people who conducted these writing exhibits said that of the 1,500 manuscripts submitted 300 would be selected for exhibit, and that of this 300 one or two would be selected as prize-winners, the prize fund being $1,000; and that they would try to sell other manuscripts (but they seldom sold one) and that when the exhibit was over they would send the manuscripts back collect, and that during the time they had them, they would try to take care of them, but would not be responsible for loss or damage. Suppose all these things, and you have a situation analogous to what painters face when they enter open exhibitions of painting. The painter, indeed, is worse off than the writer would be — he cannot send a carbon copy; he must send his original. If it is lost or damaged, his work is gone entirely.

In any other line of endeavor, any such system would be looked upon as insane; in painting it is the accepted method of getting one's work before the public.

There are, it is true, exhibitions held in many lines of endeavor.

93

They are held either for advertising purposes — like the automobile shows which display new models — or because of pride of accomplishment, like the canned fruit shown at the county fair. If the exhibits are held for advertising purposes, they are planned and operated by highly trained experts to do a selling job on every visitor; if the exhibits are simply displays of ability, then the persons who enter them have no expectation of financial return, and the people who operate them have no obligation to promote sales.

Open painting exhibitions, as usually planned and operated by museums, art galleries and related organizations, are neither fish nor fowl. Theoretically, the paintings displayed are for sale, but in the overwhelming majority of cases no effort is made to sell them, and pitifully few are sold. Theoretically, the pictures are placed in the exhibit by professional painters because they want their work seen by prospective purchasers, but in practice these exhibits are looked upon as free displays of ability, both by the public, the critics, and by the people who operate the exhibitions. Painters who send their work to open exhibits must do so on the same basis as does a hobbyist who sends his work to be shown at the county fair — that is, he must do it at some expense to himself and with little or no expectation of financial return.

The people who hold exhibits are looked upon as patrons and benefactors of the artist. Actually they ordinarily spend less money and less effort on these exhibits than do the artists who enter their work in the show. At a typical regional exhibit, the sponsors may have $1,000 available for prizes, and may spend $500 on announcements, catalogs, and incidental expenses. Suppose 300 painters submit pictures, and each of them spends (let's be conservative) $10 for a frame, $2 for crating and $3 for express to and from the exhibit. Then, together, these artists are investing $4,500 in an exhibit that is costing the sponsor $1,500 — *and this does not include the greatest single contribution the artists make: the value of the paintings.*

Actually, it costs more than $15 to send a painting to most shows. To begin with, almost every exhibit charges the artist an entry fee, which may vary from $1 to $5 or more. Frames are expensive, crating takes valuable time, and crating materials cost

money. Many exhibits require that all work be delivered uncrated, which means a charge from a picture-handling firm in the city where the exhibit is held. This will often amount to $5 or more per picture. If the pictures are insured, the painter must usually pay for that himself. All in all, a painter who considers that it will cost him $25 to send a painting to an exhibit will not be far wrong.

This expense would not be so burdensome if there were a fair likelihood of selling the painting. But an artist cannot consider the expense of entering an exhibit as an investment which offers any prospect of a fair return. He must think of it as an outlay of time, effort and money made with the only likely prospect of return being whatever prestige or critical acclaim he gains from having his work hung in the show.

This is the kind of thing that happens. You send two paintings to an exhibit. Although the exhibit opens on February 8th, the paintings must be received at the gallery by January 22nd. You ship them on January 18th.

One of them is accepted by the jury, the other rejected. Unless you can afford to pay for an extra crate, and additional express charges, the rejected painting must remain with the warehouse agent until the exhibit is over, so that the paintings can be returned together.

The exhibit closes on February 27th, and since it takes a little time to pack and return so many pictures, you get yours back on March 11th. There is a bad dent on one of the frames, and a scratch across the face of one painting. The paintings have been out of your hands for almost eight weeks, during which time one of them was exhibited for three weeks.

Since one of the paintings was not shown at all, there was no chance of its being sold, but its chances, as it turned out, were just about as good as the chances for sale in the exhibit. Out of 110 paintings that were shown, only three were sold, a batting average of .027, which is pretty bad in any league.

You spent $31 on the exhibit, and for your money you received one free copy of the exhibit catalog, and two complimentary tickets to the opening reception. If the newspaper reviews mentioned your painting, you will never know it, except acciden-

tally, for while the sponsors keep a clipping file for themselves, they send no clippings to artists.

It's a poor system. Except for the fact that painters are used to it, and accept it from habit, as if it were one of the unalterable facts of life, the open exhibit would fall of its own ponderous inefficient weight.

There has been much criticism, and some steps have been taken to improve the manner in which these exhibits are operated. Nowadays, for example, artists are usually notified as to whether their paintings have been accepted or rejected by the jury. A few years ago it often happened that a painter who sent work to a show heard nothing from it for weeks. I once wrote a fairly renowned museum and asked to have a painting returned to me, on the assumption that since they had not notified me of its acceptance, nor sent me an exhibit catalog, that it had been rejected by the jury. The museum informed me in a rather stuffy letter that the painting could not be returned, since it was on exhibit, and no painting could be removed before the exhibit closed. I later learned, quite accidentally and from another source, that my painting had been one of three reproduced in the newspaper on the day of the opening, and had received a quite favorable criticism.

So many painters complained about this kind of treatment from so many galleries that most exhibits now say, "Entrants will be notified promptly as to the decision of the jury." Quite often, the sponsors live up to this promise.

The amount of prize money has been increased in some cases, too, and purchase funds are larger. Many sponsors now pay the express charges on accepted work when it is returned at the end of the exhibit. But most exhibit sponsors have done little or nothing about trying to increase sales. Yet this is one thing that all of them could do if they approached the task realistically and intelligently.

The fact is that many museums seem to feel that there is something tawdry and "commercial" about having any part in a sales transaction. They not only fail to promote sales; they actually seek to avoid having anything to do with them. Yet the exceptions prove what can be done. The Cleveland Museum has developed

public interest in its large exhibit for local artists to the point where, in one year, sales reached $30,000.

Individually, painters can do nothing about the exhibit system. It is encouraging to note that it is better now than it was ten years ago, and that the situation may continue to improve in future years as well.

In spite of the faults in the present exhibit system which have been pointed out, the fact remains that the national and regional exhibits held each year afford the only method now available by which a painter may show what he is doing—the only place where he can compete for acceptance, critical favor and honors. Since these shows constitute your opportunity, you should enter some of them, both to gain recognition, and as one method of evaluating your work as compared to that of other painters.

This brings up the question of juries. The jury system of selecting paintings for an exhibition has been under fire from several directions, particularly since the wide diversity of present-day painting has made evaluation the debatable issue that it is. If the majority of a jury is made up of conservative painters, the *avant-garde* is indignant. If modernists predominate on the jury, the conservative painters are furious. And the two-jury system, by which each group is selected by a separate jury, seems to please neither side.

The most general and probably the soundest criticism of the jury system is that it necessarily selects by compromise, so that mediocre work, which offends no one, is accepted, and controversial work, which might add interest and variety, is rejected. Several methods have been tried in an effort to avoid this—the most successful of which is probably the system by which each juror selects a certain number of paintings to be accepted. If there are three jurors, for example, each juror selects one-third of the total number that can be hung, and these go in, regardless of what the other two jurors think of his choice.

Another variation is the "one-man jury," which leaves the selection to a single expert. This has one great merit; it usually results in a lively show, and an interesting one. But it has the defect that while it makes a more exciting and provocative show for the spectator, it leaves the painters who submit work at the

mercy of whatever whims and prejudices this particular man may have about painting. Since such an exhibit represents one man's opinion, it cannot be expected to result in a show which represents all of the widely varied viewpoints and methods of today's painters.

One of the most serious criticisms of any jury system, however, is that juries cannot possibly spend enough time to absorb, digest, and evaluate the tremendous number of paintings they are faced with and cannot, therefore, make decisions which do justice to the amount of time and effort expended by the artists whose work they are judging. At one national exhibit, for example, each painting is placed in turn on an easel, and by a show of jurors' hands is within thirty seconds either accepted or rejected without discussion. The jurors probably take longer than that to decide what they will eat for lunch. A painter who submits work which has taken weeks of earnest effort, and a lifetime of hard-won skills, and has it judged in such a peremptory fashion, is not only being treated unfairly, he is being insulted.

But the jury system is like the whole system of open exhibitions in this respect: There is nothing much that the individual painter can do about it. It is the only system available, and while it has many faults, it has got to be lived with, and used, because there is nothing better available. About all a painter can do is select the exhibits he will enter as carefully and wisely as he can by getting the answers to as many of the following questions as possible.

What percentage of work submitted is accepted? If an exhibit usually gets 1,500 entries, and accepts 150 paintings, then the numerical chances against acceptance are ten to one. If 200 paintings are submitted, and 100 are hung, then its an even money bet that you'll get in.

Who will make up the jury? Are they persons whose opinions you respect? There is little use of submitting your work to a jury whose members are avowedly antagonistic toward the kind of painting you believe in. It is not always easy to determine this, and it is easy to be mistaken. It is my own belief that while the jury system has faults, there is no question but that individual jurors always take their job very seriously, and that they try to

be as objective as possible. So don't worry primarily about the jury. Send the best work you have. It will get the same treatment and the same consideration as every other painting submitted, even though that may be more cursory than you could wish. If it is rejected, you can blame the system of judging, and quite possibly be right. But you can't blame the individual jurors, who did the best they could according to their lights.

What is the sales record of the exhibit, and what is the sponsor's attitude toward sales? If sales are usually numerous, then that fact makes entering an exhibit a sounder venture. If there is a poor sales record, or if those in charge are unwilling to announce what their sales record is, which may mean it is pretty bad, then the exhibit must be judged on the basis of the recognition and prestige you will gain if your work is accepted.

Almost every exhibit offers prizes, both as awards, which are sums given outright, and as purchase prizes, which are sums given to the artist for which he sells his work to the sponsoring institution. These prizes are, of course, a fine thing to receive, but they are as unpredictable as being struck by lightning. Over a period of years, a painter who submits pictures to many exhibits will, if his work has merit, win an award now and then. They are nice things to list on a biographical data sheet, but no one is likely to get rich from the awards he wins. My own idea is that a painter should try to keep out of his mind any notion that his work will win a prize. Then he will not be disappointed so often, and when a prize does fall in his lap, it will shine with the special lustre that only the unexpected can ever have.

Lists of forthcoming exhibits are carried in the *American Artist* and in other art magazines. These listings give the following information: the nature of the work to be shown and the media to be used; whether the show is for all artists, or is limited to those in certain areas; the entry fee; the number of entries permitted to each artist; whether or not there will be a jury; the dates of the exhibit, and the date work must be submitted; and finally, the name and address of the person to write to for applications. There is usually also the word, "Prizes," and sometimes, but not often, the amount of money to be awarded.

When you write for an application, you will be sent a pro-

spectus, giving the rules under which the exhibit operates, the list of prizes to be awarded, the names (usually but not always) of the jurors, and an application blank. By filling out this blank, and sending it in with the required entry fee, you agree to abide by the rules of the exhibit and the decision of the jury, and you are entitled to entry blanks, which are usually mailed to you quite promptly.

These entry blanks are sometimes simple mimeographed slips; sometimes they are elaborate strips of cardboard eighteen inches long, and perforated in ten or twelve places, as complicated as a transcontinental railroad ticket, and as laborious to fill out. But even the gaudiest ones are self-explanatory in their own obscure way. Usually one part is to be tacked to your painting, and the other part is to be mailed in to the sponsor. I often wonder if the process needs to be as complicated as they make it.

Regional exhibits usually offer a better chance for acceptance, and since they are near-by, are usually less expensive to enter. Some regional exhibits, like the one in Cleveland, offer even better sales opportunities than do more widely known national exhibits.

In recent years there has been an increasing number of outdoor exhibits and art festivals, usually open to everyone, with no jury. Some of these have achieved remarkable proportions and impressive sales records. One of the largest, the Virginia Beach Boardwalk Show, held each July, started ten years ago with thirty artists, and with a prize list consisting of five copies of this book. This year, there were more than three hundred artists from all over the country; prize money was $1300; and sales were more than $30,000 in four days. The California show at Laguna Beach is said to be even larger.

The only drawback at Virginia Beach is the execrable quality of much of the work exhibited. Acres of frighteningly bad pictures overwhelm the works of the small number of competent painters. The juryless show, it seems, attracts not only the amateur of uncertain talent, but also the cold-blooded opportunist who paints cynically bad pictures in order to make a buck from the innocent. It would be nice if there were some way to separate the hacks from the sincere artists; not that sincerity is enough—it is the most overrated of the virtues. So many people are utterly sincere

and at the same time utterly wrong. But sincerity is better than crass mendacity, if one has to make the choice, and in the case of these outdoor shows the choice may become necessary. Otherwise, Gresham's Law will take over completely and the bad work will drive out the good, as has already happened at Virginia Beach.

They say the show at Virginia Beach is lots of fun, and can be quite profitable. It does several things this book advocates: it puts paintings where lots of people can see them; it brings the artist into contact with the public under informal and friendly conditions; and it gives the beginning artist a market place he would otherwise not have. It is too bad that in some cases the quality of the exhibited work is so shamefully low.

If you paint fairly well, and if you need a chance to exhibit, one of these outdoor shows might help. The shows are listed among "Coming Exhibits" in the magazines, and they are a way to sell paintings. No matter how modest an opinion you have of your own work, it is better than a lot of the work you'll be competing with, and more honest, too, I have no doubt.

Unless the exhibit you want to enter is a local one, you will have to ship your paintings. Express shipment is the most satisfactory method. The express company is used to handling paintings, and handles each package individually. They will pick up your package from your studio and, when it comes back, they will deliver it to your door again.

They are rather particular about how paintings must be packed. You may get an express agent to accept a cardboard carton once in awhile, but most of them will insist on a wooden or plyboard box, with no wide openings between boards through which anything might be punched. And this is proper. Nothing else offers the same complete protection against damage.

Such a box is not hard to make. Lay your painting on the floor. If there are two or more paintings, stack them in a pile, with strips of corrugated cardboard between them to prevent rubbing. Now measure the thickness of the painting, or paintings, from the floor to the upper edge of the top frame. Add an extra ¼" for packing, and then find a pine board (or buy one at a lumber yard) as wide as this measurement. The board should be about ¾" thick and long enough so you can saw it up and make a frame completely around

your paintings. Don't forget that while two lengths of the board should be just as long as the paintings are in one direction, the other two must be the length of the paintings' other dimension *plus twice the thickness of the board,* so the corners of the box you are making can overlap and be nailed together. If you are thoroughly confused by this time, the sketch shows exactly what is meant.

Now get two pieces of ¼" plywood the size of the box you have made. (Plywood comes in various grades, but the cheapest is quite suitable for your purpose.) Nail one of the pieces of plywood in place, put the paintings inside the box, and wedge them firmly in place around the edges with wads of folded newspaper.

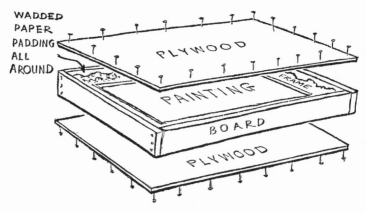

How a picture is crated for shipment. The boards around the sides are nailed together first. Then the bottom plywood is put on, and the painting firmly wedged in place with wadded paper. This padding should extend a little above the edges of the boards, so that when the top plywood is pressed down, the painting will be firmly held.

Add enough wadded paper on top to prevent any movement of the paintings, and then press the top piece of plywood down and nail it in place. When the box is completed, the paintings should be so snugly packed that they cannot shift or rub even when the box is shaken or bumped.

This kind of box is relatively easy to build and makes a neat, strong unit which can be used over and over.

If paintings are covered with glass, masking tape should be

applied to the glass in a lattice pattern to help prevent breakage, and to hold the glass in place if it is broken, and so prevent damage to the painting. If your frame is ornate or fragile, wadded crepe paper fastened around it with Scotch tape will help prevent damage to it.

In shipping prints or watercolors which are matted but not framed, a simple and strong package can be made by using two pieces of $\frac{3}{16}$" beaver board, cut about an inch larger all around than the largest mat. Place the matted pictures on one of the sheets of beaver board, separated from each other by tracing paper, and then put the other sheet of board on top, like the top slice of bread on a sandwich, and tape the two boards together *all the way around* with gummed Kraft tape. Do not use Scotch tape or masking tape for this purpose. Use heavy Kraft paper gummed tape at least two inches wide, and be sure it is stuck tight.

This kind of package should be sent by express because the vagaries of the postal code make first-class rates apply to a sealed package, unless you state that the package may be opened for postal inspection. The idea of somebody opening my package to see if I am a crook or an honest man has always irritated me.

Packages should be insured, and insurance rates on express shipments are nominal unless you value your package at $550 or more. At that figure or above it, you get into all kinds of complications. If you are going to ship something valued in this category, get the express company to explain the rates to you in advance. They've explained them to me several times, and I am still a little vague on the subject.

As for insurance in general, the fact is that when a museum or other institution accepts your paintings for exhibit, they should accept the responsibility for their safety. They should, but usually they don't. They say that they will be "careful," and that they will "take every precaution," but these statements are nothing but a pious hope. If your painting comes back with a hole in it, these assurances make poor reading. And if you happen into a museum just before an exhibit and see paintings stacked ten deep against the walls, or piled haphazardly on a dolly and carted bumpily on a flat wheel across six galleries, you will wonder if they know what they are talking about.

There is a form of insurance available called a "fine arts floater" which insures your work against any kind of loss or damage, anywhere. It costs a considerable amount and, even at that, it is often difficult to find an insurance agent willing to write such a policy unless he likes you, or feels sorry for you, or both. My own philosophy is to insure packages which I ship, and then put my trust hopefully in the museum. If the picture comes back damaged, I complain. It never has done me any good, but I complain anyhow.

In entering open exhibits, a painter must develop a philosophical attitude. If your picture is rejected, it is bound to make you feel bad. If it is accepted, you are elated. But in either case, the jury may have been mistaken in their decision. You never know for sure.

After awhile, you will discover that you really never do know for sure. Several years ago I got a picture back from an American Water Color Society exhibit, and sent it to a small local exhibit in a North Carolina city. The local exhibit jury turned it down, but they accepted another painting of mine — one that the Water Color Society jury had rejected.

Every painter who exhibits regularly has these experiences. All they prove is that each jury is different, and that all of them are unpredictable.

You won't get accepted by every exhibit you enter. For awhile you may get turned down most of the time. Don't let it influence you to try to please the juries. That is a stupid game, played only by fools. Keep sending them the best work you can do, and keep working to make it better. If you have a future, it is a future as an individual.

XIII · The Painter and the Public

IF YOU PAINT in a public place, someone will come along and look over your shoulder. A great many people will — and your reaction to this fact is of considerable importance, not so much because of the individuals themselves, but because your feelings toward them are likely to be an indication of your attitude toward the general public. And your attitude toward the public has a definite bearing on your life as a painter.

About half the people who come along will tell you they have a cousin who "can paint" — or an aunt, or a sister, or a nephew. They will tell you how talented and versatile this relative is; and his ability is always remarkable. This used to bore me until it was pointed out by a psychiatrist whom I see every day (I am married to her; it is a great advantage for a painter to have a wife who is a psychiatrist) — as I was saying, it was pointed out to me that these people were trying to find some common ground — that they were reaching out in an effort to identify themselves with painting in some way, and that the intention was utter friendliness. Experience has shown that this is true.

The people who stop to talk to you, and to look at what you are doing, are, at the least, displaying curiosity, which is a healthy and admirable thing. At the best, they are deeply interested — and interesting — people.

All of them have in common a latent desire to know more about painting, to have some contact with painting. To most of them the art of painting is a fascinating but mysterious thing. They have never seen a picture being painted. They are self-conscious because "they don't know much about art."

But when they see a man painting, not dressed in a beret and a smock, but wearing clothes pretty much like any other working man — when they find that his attitude is not distant and cool, but friendly — their pleasure in the event is warm and rewarding.

If you know many painters, you know that they are nothing like the strange exotic breed that the movies and the journalists have pictured to the public. Artists, who are in reality a deeply serious and hard-working group, without any more affectation or peculiarity than will be found in any other group, are generally pictured in popular fiction, in the movies, and on television either as zany figures with ludicrous delusions of grandeur, or as sad, self-pitying hams. When a person is introduced to a doctor, or a banker, or an engineer, he expects this new acquaintance to be a fairly normal individual, but when he is introduced to an artist, he often expects to find a pretty queer character, if not actually a goof.

If you are cool or distant to the man-in-the-street, you are deepening this misunderstanding. If you accept his friendliness and his interest, you may help him arrive at a new understanding of painters — what they are really like, and what they are trying to do.

I happen to believe that this is important. If painters are neglected or ignored, it is not through lack of interest on the public's part, but through lack of understanding. To develop understanding, to reinforce interest, there is nothing so powerful as a sympathetic personal relationship. If you know a fellow, and have watched him work, and talked to him about that work, you are more than apt to be interested in the results. It is the purpose of painting to communicate emotions, and the wider the audience, the better for the painter — and for his audience.

If, like many painters, you do not make sketches on the spot, but work only in your studio, you miss both the inconveniences

and the opportunities that come to those who work out-of-doors. Many painters say that they are unable to work direct from nature, that they are better able to paint in a truly creative vein when they work entirely from memory or imagination.

This is true, to a greater or lesser degree, I suppose, for every painter. But even for those who work entirely in the peace and quiet of a studio, I would recommend an occasional venture with an easel into the bustle and noise of the streets. It has distractions: the heat, the insects, the dust, the noise combine to your discomfort. And there is a woman behind you who says, "My, how pretty," and tells you about her niece, who can "look at anybody and draw them so it looks just like a photograph." Count to ten. Remember, she wants to be friendly. She is reaching out to find something you and she have in common. She is in need of beauty and meaning in life, as is every one of the myriad of people who throng past you. And it is from the fine arts, from painting, and from you as a painter, that these things must come, if they come at all.

If you are patient and really try to like people, some nice things happen. Once I was sitting in the railroad yard in Durham, North Carolina, doing a sketch of a locomotive which had stopped at a water tank. A man came over to see what I was doing. "That's my engine you're painting," he said.

"That so?" I said.

"Yep. Only engine on this division with those brass handrails." He watched me for a minute. "How long's it gonna take to finish that?" he asked, looking at his watch.

I told him it would be about twenty minutes. He watched carefully, warning me about some pipes from the sandbox that I had neglected to notice. Finally, I sat back and told him I thought that was about it.

"Sure you're through?" he asked. I told him I was.

"Well, if that's all, I'd better be pullin' out," he said. "I'm ten minutes late already." And a few moments later he came past where I sat—pulling seventeen passenger cars full of people, and waving good-bye from the engine cab. It was a very real compliment.

I suppose everyone agrees that it would be a good thing if more

people were interested in painting; if more of them developed appreciation and good taste; if more of them owned paintings of merit. It would be a good thing for them because it would make their lives fuller and happier; and it would be a good thing for painters because they would then have a bigger audience, and a wider market.

One of the things that painting in public will teach you, if you meet halfway the friendliness of those who stop and talk, is that somewhere in every one of them is a spark of interest, and as you talk to them, it brightens.

Even from those from whom you least expect it will come interest and understanding. I painted the interior of a deserted house, with a fireplace of worn wood, the floor covered with rubble, and the door open on a weedy yard. When it was hung in one of the exhibits to which I sent it, a critic said it had "nostalgic overtones." But I remembered the old and ragged Negro who watched me paint it. When it was finished, he looked at it and said, "There's many a fire been built in that fireplace." What the critic felt, the old Negro felt. I thought he said it more simply, and better.

There are far greater satisfactions in painting than can come from the studied and antiseptic praise of the elite. By painting to interpret the world around you to the people around you, you gain a feeling of usefulness. You are part of a cycle — each day shows life to you, and you, in turn, give back something which you hope will light a corner of that life with clearer meaning.

The juries and the critics do not particularly *need* what you have to offer. If your work has merit, it is the world of your fellow men that needs it. And you will learn, I think, that if painting today has no integral part in the lives of most people it is more because the artists have deserted the people than because the people have lost interest in the artists.

Besides your relations with the public, there is the question of your relations with other painters. If you live in a community which has a local art group, you will sooner or later be invited to join. Considered as a social contact, membership in such a group may be pleasant, but in most cases you cannot expect that it will serve any other purpose.

These art clubs, too often, are burdened with ineffectuals who paint as a hobby, and paint very badly. It is no disgrace to paint badly, but it is hopeless to paint badly without knowing it. In addition, the atmosphere in which most clubs operate favors the growth of the mannered, the pretentious, and the pseudo-bohemian.

There are capable, serious painters in these groups, too. But they are generally outnumbered and always out-talked by those to whom painting is a game. These people, even when they paint well, have an attitude toward painting which must be described, I'm afraid, as that of a dilettante. And there is no one so certain of his qualifications as an oracle of the revealed and immutable truth about "Art" as is the competent dilettante. If he (or more often, she) has studied under O'Hara or Farnsworth, he is pontifical. If he has had paintings in a few shows, he is patronizing *and* pontifical. If he has been abroad, he is, in addition, boring.

Aside from the fact that such people are more irritating than they are amusing, they will waste your time. These painters and the organizations they dominate use painting as a social outlet — and any time you devote to such a group must be thought of in that way. If you expect to develop as a painter, and to make a living by painting, you will not have time for such playing, nor will it help you.

Before you join any organization, ask yourself these questions: Will it help me be a better painter? The answer to this is that learning to paint is not a group activity. You will not go far wrong if you follow this rule: See as many paintings as possible, and as few artists as possible.

Will joining a local art group help me gain recognition? The answer to this is generally "No." The level of work is extremely uneven, and the critical standard is low. Being thought of as a member of such a group will classify you with the incompetents who make up much of the membership, and with the quasi-intellectuals who dominate it.

Will art club membership help me sell paintings? No, almost categorically, it will not. Most of the members are not primarily interested in selling paintings. Getting their work exhibited and complimented is their aim, and the reward they are after. They

put prices on their paintings when they exhibit — outrageous prices — but most of them do not sell three paintings a year, nor do they expect to. Art club exhibits, in fact, attract few people other than friends of the members.

Will art club membership be rewarding as a social contact? Well, if you like cocktail parties, if you enjoy the potpourri of empty compliment and veiled knifing that passes for conversation at these gatherings, maybe so. But you will not learn much. It is just about impossible to carry on a down-to-earth constructive conversation about painting with these people.

There are exceptions. You will find a painter or two in your community with whom you can reach common ground. But such a friendship is a different kind of thing. With such a person you can discuss painting as painting. He will say, "Your values are out down here at the lower right." You will say, "Why don't you sharpen the contrast here, and move this line to compensate for it?" And you will get somewhere. This has nothing to do with membership in most art groups, where art discussion is cosmic and gaseous.

Perhaps there are art clubs in some cities which are worthwhile — whose membership is made up of the sincere, the serious and the competent. If so, I apologize to them. I have never had the good fortune to run across one. Perhaps you will.

How can you tell? Attend a few exhibits of the club and see what kind of work the members are doing. That is the real test, of course. And talk to them. Do they get their teeth into a discussion? Do they get excited? Or indignant? Or is their talk the puffy, namby-pamby chatter of the ladies club, or the high-flown metaphysics of the cultist? You can tell pretty soon. As a final test, you might follow my own rule for evaluating organizations, to wit: The merit of any organization is in inverse ratio to the gallonage of tea and/or cocktails consumed by the membership.

What I am recommending in this chapter may seem strange: That a painter should meet with a cordial welcome the advances of the public, who know nothing about painting, and that he should stay away from art groups except for those painters whom he likes and admires very much.

Here are the reasons for that advice. Painters have, as a class, kept themselves aloof from people in the mass, with the result

that those people have very little knowledge of what painters are actually like, and what they are trying to do. Instead, they have developed distorted ideas — ideas which have been strengthened by the fact that only those painters who exhibit bizarre behavior or inexplicable pictures usually make the headlines.

An artist, by associating only with art groups and with other painters, and by developing in this insulated atmosphere the notion that painters are a very special and intellectual group not properly appreciated by the world, helps widen the gap. As long as artists ignore the public and show interest only in their own elite group, just so long will the public ignore the artists' work. This is undesirable, both for the public and for the painter.

Basically, it is snobbery that curses the relationship of artist and public. And the saddest part of it is that most artists are not snobs at all. It is the sycophant, the dilettante, the flutterer around the artist, who is the snob. There is a hunger for understanding that painters have; they would like to have their work accepted. Then comes the aesthete who says, "I understand — come in out of the cold, come in where the atmosphere is congenial, where you will be appreciated." And he leads the painter into a warm, sunny room, protected from the weather in the streets, where the most exotic flowers may grow in lush profusion.

But it is a hothouse — and what the world needs is not a hothouse for art, where a few connoisseurs visit to admire the delicate blooms. What the world needs is an art that grows, like goldenrod and Queen Anne's lace, along all the dusty roads that men travel and lifts the heart of every wayfarer.

Most museums, and particularly those in the South, have (quite unwittingly) kept painting from reaching more people by making art exhibits into social events. I have personally drunk enough tea in the presence of well-meaning ladies in wide hats to have drowned a shorter man. This insistence upon tea is in spite of the fact that most painters are not thirsty — they are hungry. When an art exhibit opens with a tea, or a cocktail party, this fact attracts a certain group — and at the same time, it effectively eliminates any chance that nine out of ten people will come at all.

I paint out-of-doors a great deal. I have made it a point to ask

people who stop and talk to me how often they visit the local museum. Ninety-five per cent of them have never been in it. Yet the museum is a tax-supported institution, theoretically dedicated to the use of all the city's people. The difficulty is that it is operated by and for a certain social group, as if it were a country club.

This is not done willfully, and it is not an exceptional case. It is, in fact, typical. The groups who dominate the museum's operation are quite sincere in thinking that they *are* the people of Norfolk—quite sincere and entirely wrong. They would be hurt to know that their social events, requiring fine clothing and drawing room manners, have set up a barrier which shuts out most of the city's people. And yet that is exactly what has happened.

It would be possible, and I think desirable, to promote an art exhibit so that the general public would attend, and to operate it so that once there they would feel welcome and at ease. When that is done generally—when the art of painting is given an opportunity to reach the wide audience that it needs, and that needs it—then the painter's usefulness and his opportunities will find new horizons.

It is not lack of ability, or lack of originality, or lack of accomplishment that today's painters suffer from—it is simply lack of audience.

The way to create that audience is not by the segregation of artists and their present followers from the world. The way we painters can create that audience is by becoming part of the world, by living among people, and becoming part of their lives, by meeting their friendly advances with friendliness, and by placing the results of our work before them—before all of them, as something that was done for them, and for everyone.

XIV · Speaking in Public

Sooner or later you will be asked to speak before some group about "Art." And if members of the group are impressed by your talk, there will be more and more such invitations. Program chairmen are always looking for good speakers who have something new and interesting to say.

If you have never talked in public, such invitations may be frightening. The first time it happened to me, I was scared to death. But I have found, as you will, that the people in these audiences are anxious to like you. After two or three talks you will not be afraid of them any more. You may even begin to enjoy speaking in public.

But even though you may dread the ordeal, such opportunities are valuable from the standpoint of publicity. People who hear you speak may be interested in seeing your work. The general public has little contact with artists, and little understanding of the work artists are trying to do. The average man is a little afraid of the subject because of this ignorance, but he is curious, and such contacts often awaken the latent interest in painting which lies dormant in almost everyone.

When you are invited to speak, remember, however, that what audiences want first of all is entertainment. Any serious message

you feel impelled to give them must be well-disguised with a sugar-coating of humor. Few audiences will be interested in a technical discussion of painting, or in art criticism, or in the history of art. They will be interested in anecdotes which illustrate the personalities and the philosophies of painters. They will be glad if you can make them feel that painting is done for them, and that they have a right to an opinion about it.

These talks offer the best possible opportunity for painters to make it known that artists are not (as too many people feel) some strange introverted breed practicing an occult profession which bears no relationship to everyday affairs; but that they are normal and friendly people, practicing a craft which they hope will have meaning for everyone; and that painting can and should make life more meaningful, and happier.

This has to be done lightly, and the content of your talk should vary with the interests of your audience. As examples of how your approach may be varied, these are some of the talks that I have developed for groups of various kinds.

(1) "The Care and Feeding of Artists." A twenty minute talk for use at men's luncheon clubs, such as Rotary or Kiwanis. It accepts good-naturedly the fun often poked at artists, by beginning with a couple of stories in which the idiosyncrasies of artists are the topic. Then it attempts to put over the idea that artists are not the peculiar characters that they are usually pictured as being, but pretty normal and pretty useful individuals. It ends seriously, with the thought that art is kept alive, not by painters and not by museums, but by the interest and support of people who have come to realize that painting is of value to society, and to each of them individually.

(2) "What Artists Think About" or "Making Chesapeake Bay Match Your Sofa." This is a thirty minute talk for women's clubs. It is in reality a discussion of what constitutes a "patron of the arts." Most women's organizations feel that they are leaders in cultural affairs, but most of them do little about it in any concrete way, either as a group or individually. It is impossible to say this to them directly without antagonizing them. This talk tries to do so indirectly, by showing what constitutes a real interest in painting, and pointing out, by inference, that the only real patron of the arts is a steady customer.

(3) "The Influence of Painting on Religious Concepts." This takes thirty minutes, and discusses the fact that everyone's mental images of religious scenes and characters are almost wholly derived from the creative talent of artists. It goes on to point out that one of the functions of the painter is to crystallize man's dreams in this way, and give them form — and that this is true of every one of man's activities. The talk is intended for church groups.

(4) "Watercolor Painting." A talk for groups of amateur artists, and for art clubs in general. It is somewhat more technical than any of the others, and discusses the history of watercolors, mentions the work of various outstanding men in the field, and their contributions to the medium. It goes into methods of painting in a general way, and concludes with a ten minute color film which shows the painting of a watercolor. The talk and film take about forty minutes, and at this kind of meeting I usually end with a question and answer period.

(5) "The Purposes of Painting — Communication vs. Self-Expression." This is a more serious talk, originally written for use before a group of professional men. It discusses present trends in painting, and the philosophies behind them, in an objective manner, and tries to examine the nature of the artist's function in today's society. It is about fifty minutes long.

How do you prepare for a talk? First, inquire carefully as to the kind of audience you will have. Do they consider themselves an "intellectual" group, or do they meet for recreational purposes? Are they already interested in painting, or will you have to try to create that interest? Are they young people, or old, or a mixed age group? How many people are apt to be there? This last is important because a talk that would be suitable for a group of several hundred in an auditorium will be far too formal for thirty people in a church parlor.

When the invitation comes, find out, if you can, what they would like to have you talk about. Usually you will get no satisfactory answer to this question. The program chairman will insist on leaving the topic up to you, but by suggesting several alternatives you may be able to get him to express a preference.

Find out — and this is of vital importance — how long you are supposed to talk and what time you should finish. Most meetings follow an established pattern, and those who attend will expect the meeting to be over at a certain time. At luncheon clubs attended by business men it is especially important to get through on the button, and this may not be as simple as it sounds. Quite often the preliminaries take longer than anticipated. You have been told that you will have twenty-five minutes, and you are introduced at 1:40 with a twenty-five minute speech to deliver and a 2:00 o'clock deadline. Be prepared for this by deciding in advance what can be left out. Do not hurry your delivery but, by skipping the unessential, cut your talk to fit the time you have. Whatever they think of you as a speaker, or as a painter, they will at least remember you fondly as the man who got through on schedule.

Write down what you are going to say. Don't just make notes, write down every word. Read it aloud and time yourself. Then practice it before a mirror, or better yet, before a couple of friends who will give you a frank criticism. Finally, even if you are certain that you know every word of it by heart, take a double-spaced typewritten manuscript along, lay it down in front of you, and turn the pages as you go along. You will thus certainly avoid the most ghastly thing that can happen to a speaker — forgetting what comes next. It is better to read your talk directly from the manuscript than to labor haltingly through an imperfectly remembered speech.

If you have never spoken in public, pick out small groups to begin with, and learn by doing. It might even be worth-while to take an evening course in public speaking, if one is available, because if you succeed as a painter, you will certainly be faced many times with the necessity of talking before an audience. Plus this, if you become a really good speaker, this ability can occasionally be profitable to you. Many art clubs pay speakers of established merit for lectures on subjects in their field. These lecture fees are seldom less than $50, and often are $100 or more.

Finally, remember that the best speaker is one who believes in what he says. Do not take yourself too seriously, but take the subject of painting seriously always.

XV · Keeping the Spirit Alive

THE EXPLORATION of new techniques, new materials, and new ways of looking at the world have been the valuable contributions to painting by the artists of this generation. Painting pictures is a search for beauty, and the willingness—more than that—the *determination* to seek out new and personal avenues toward that goal must be a never-ending struggle. The search leads down a lot of blind alleys; ends up sometimes in deserts of sterility. Once in a while, a painter cuts through the underbrush of convention and comes out on an hitherto unexplored hilltop with a great view of the world.

The greatest hazard faced by a painter who wants to make a living from his work is that he will experiment only until he finds a road to the market place, and arriving there, will settle down to produce and sell his wares. If you read this book with the idea that it is simply a guide to that market place, then it will have failed you, no matter how much money you make. That is not the purpose of this book—its purpose is to help a painter, who paints as he pleases, to sell his work for enough money to support him while he continues to explore a path toward beauty.

Keeping the morning freshness is the difficult but necessary requirement. Almost everyone begins to paint with the highest

117

hopes, and if he works hard, sees his work improve; but it becomes a slow and discouraging process. If he gets to a plateau that's comfortable, there is a danger that the painter may sit down to enjoy the warm breeze of acceptance almost certain to be blowing there.

Having beaten that metaphor to a pulp, let me be more specific. When you meet a really creative artist, you are sure to find that he has an overwhelming gift for enthusiasm. Not that he is necessarily an extrovert—he may be very quiet—but when you get close to him, you can feel the hum of the dynamo that runs day and night, and lights up the surroundings. That is why so many great artists seem so much younger than they are; the spirit that drove them into painting is still there.

Everyone has periods when enthusiasm wanes. Painting can be a discouraging business. I sometimes think the most discouraging aspect of painting is when you do a piece of work that makes you happy, you know the jag you're on won't last; but when you have a series of failures, you become certain that it will last forever. When a ball-player gets into a batting slump he changes his stance, tries drag bunts, chokes up on the bat—experiments in every way he can think of—but he keeps going up there and taking his cuts at the ball. And that's what you have to do.

When you get into a slump, try a different medium. If you seem to be at a dead end with oils, try watercolors, or cut a wood block, or make an etching. Trying a new approach to the same medium may help. I once got out of a deep rut by painting a series of watercolors on smooth bristol board rather than the rough paper I had been using. The smooth surface created difficulties, and in solving those difficulties I developed a fresh interest in the medium.

Sometimes a new approach to subject matter may be the answer. Once, when I couldn't face the idea of doing another watercolor because I felt sure it would be as bad as the last one I had done, I was sitting on a bench staring at the ground, and after a while I noticed that I was looking at a dandelion growing up between the bricks of the sidewalk. I made a meticulous painting of it, and that was the beginning of an absorbing series of pictures of the small beauties of life; a board with a rusted bolt through it; the

rudder of a tugboat on the ways; an axe in an oak stump; the wooden latch on an old gate; a length of worn rope in the sand.

If your work is to have permanent value, it will be because you become able to communicate to others the beauty you see around you. You start with an advantage you may not have considered— no one else sees the world exactly as you do. I have often gone out on a sketching junket with two or three other painters. Sometimes we all paint the same subject from the same spot, but we end up with paintings as different as our personalities, because we see different aspects of the subject—not purposely, but inevitably.

That is where the necessity for enthusiasm becomes vital. You must believe in what you yourself see, expressed as you, and only you, can express it. You have got to think this is important—more important than anything else in your life—more important than praise, or prizes, or making a living. If it is not that important, then you have no real purpose in painting.

XVI · Commissioned Work

THE HAPPIEST ADVANTAGE you have as an artist is that you can paint what you please, and paint it in any way your fancy leads you. Bear this in mind when someone comes to you and says he wants you to paint a picture of his estate, or his horse, or his factory, or his prize camellias. You may be losing more in freedom than you gain in money.

If I could always afford the luxury of refusal, I think I would never accept a commission. A constricting force tightens around you when you do commissioned work, so slight, sometimes, that you aren't conscious it is there, but it inevitably affects the result. I have talked to many painters about this and almost everyone recognizes the added strain, and admits readily that commissioned work rarely turns out as well as the work they do independently.

Some companies that commission artists recognize this problem, and carefully give the painter all the freedom possible. When I had been hired to do my first work for the Humble Oil and Refining Company, the advertising manager drew a circle on a map of Texas—a circle that took in most of the country between Midland and the New Mexico border. "Stay inside that line," he said, "and paint whatever interests you." I painted a carbon black factory that belonged, it happened, to Phillips Petroleum, but I

got a lot of Humble stuff, too, and they seemed happy. On another Humble assignment I hung around the research laboratory and painted any activity I liked, with no suggestions or advice from anybody. The Humble Company says they get better work that way, and I believe it.

Not very many people are as sensitive to the artist's problems. Because I occasionally paint old houses, and have painted many pictures of Colonial Williamsburg, people ask me to paint a picture of their home, which they intend to hang in their living room. Their reason for wanting such a painting for such a purpose baffles me. If they like the looks of their house, I would think the thing to do would be to walk out a hundred feet or so and look at it. To complicate the problem, many of the houses have all the charm of a bakery birthday cake, and the wife says, "I know how you artists are, and I wouldn't dare make a suggestion, but the walls in the room where the painting will hang are a pale brown, so wouldn't it be a good idea to have the trees in fall colors?" Things like this give artists a reputation for being moody and incoherent.

It is not hard to say "No" in such cases. It is a pleasant necessity. But when a good customer who has bought many paintings asks for something, it gets harder to turn him down. A bank for which I have done much work asked me several years ago to paint some watercolors of the Norfolk Naval Base to hang in their office located near the Base. I got permission to sketch on the Base and found the subject matter fascinating. At the destroyer-escort piers, I made a sketch of three destroyers tied up side-by-side, head on, with the intricate web of their masts and radar forming a powerful abstract pattern against a stormy sky. I don't like a lot that I do, but I thought this one was pretty good.

When I took it to the bank I had a sad surprise. The bank president thought it was "too strong and too threatening looking." He asked why I couldn't instead do a painting of the U. S. S. North Carolina under way, with maybe a blue sky. He had been a guest on the ship once, he said, and he thought the Admiral would be pleased if we used that ship in the painting, but it ought not to be on a stormy day.

I told the bank president the story about Haddon Sundblum and the new Buick, a story which may be apocryphal, but makes

clear a point otherwise hard to explain. It is said that Sundblum, one of the best commercial artists of this century, was once commissioned to paint a picture of the new Buick for some year or other, to be used in the company's advertising. He brought the finished painting before the Sales Manager, the Chief Engineer, and the President of the company for their approval. The Sales Manager said, "We're playing up the massive bumper this year. Can you make it bulkier looking?" Sundblum said he could, and made a note of it.

"The steering wheel ought to slant more vertically," said the Chief Engineer. "We've changed the angle." Sundblum nodded, and made a note.

The President spoke: "I don't like the color of the sky."

"You," said Sundblum, "can go to hell."

Everybody seems to understand the point of that story except company presidents who buy paintings. I don't think the bank president understood the distinction I was making. Even after I wrote him a two-page letter, explaining why I was resigning the commission, he was puzzled about it, and told people I was a strange fellow who couldn't take criticism.

This particular story, however, has a happy ending, which proves it's a good idea to stick to your guns, if it proves anything. More than three years later, the bank president phoned me and asked if he could send a car for me, because he wanted to talk to me. It was the only time in my life anybody offered to send a car for me, and it impressed me tremendously with my own importance, but I resisted the impulse to give in, and said I'd drive down in my own car.

He wanted some more paintings. That was seven years ago, and he hasn't given me any advice since, although I've done much more work for him than I had done before the argument about the Naval Base. He still tells people I'm a funny fellow, and very touchy about my work. We even have a tired joke about it. He says I'm not to lend money (an idea that both of us find hilarious) and he won't paint pictures.

In relating this story I do not want to seem ungrateful to a man who has been patient, generous and kind. I admire him greatly, and I think he likes me. It is the difficulty of communication that

I have been trying to point out. If I could make clear to him how it feels to be a painter, and what it requires of me; and if he could make clear to me what it is like to be a bank president, and what that requires of him, everything would be simple. It is never, in fact, simple, but very complicated. Often, after an effort to explain why something is impossible (when I oppose it) or necessary (when I favor it) I end by shrugging my shoulders and throwing out my hands; and my would-be patron ends by smiling patiently and shaking his head.

The important distinction is that between information and opinion. I am sure it is obvious to most artists, even though it proves so difficult for many patrons. When I wanted to put a naval aviator in a mural, I got one to pose in his flying clothes, and was careful about every button and wire; when I drew a Virginia pioneer, I looked up the way a frontiersman fastened his shirt in 1650; the day my wife looked at a sketch I had done and said, "My Lord, no woman holds a baby like that!" I got a doll and made her show me the proper technique. All these things are matters of fact, and when an artist takes liberties with fact, there should be a good reason for it, as there often is—but the reason should never be carelessness excused as artistic license.

If you can make clear to your patron that on commissioned work you welcome all the pertinent information he can give you, but that how this information is used is your problem alone, you will simplify the handling of commissioned work amazingly. This is a distinction many patrons find difficult, however, and one that they keep forgetting.

When you accept commissioned work there are certain things to be careful of: (1) Quote a price of at least 50% higher than you would expect to get for the same painting done independently, because you will spend more time on it, and more worry. (2) Write the customer a letter setting forth your understanding of what he wants, the conditions under which you agree to do the job, the medium to be used, the size of the painting, the cost, and the delivery date. Ask him to give you a letter agreeing to these terms. Then you have a contract, and in addition, a firm basis for understanding. It avoids "I thought you meant" and "I assumed you knew" and all the other outriders of misunderstanding and bitterness.

Before you accept any commission, consider the odds you face. When you paint a picture, you are undertaking to satisfy your own definition of excellence, a most difficult and discouraging task. When you accept a commission, you are also undertaking to satisfy someone else's requirements for excellence, a task even more difficult and discouraging, if that's possible. If you please yourself you are lucky; if you please your customer you are extremely lucky; and if you expect to do both very often, you are going to be badly disappointed.

The best answer, if you value your peace of mind, would be to do no commissioned work at all. If you accept any, take only those which seem interesting and desirable. If you undertake more than that you will be making a mistake, injuring your future as an artist, and getting yourself into all kinds of difficulty and unhappiness.

XVII · The Reproduction of Your Work

THE FIRST TIME you see one of your paintings printed in a newspaper or magazine is a thrill. After it has happened a few times, you begin to look at the quality of the reproduction with a more critical eye; and one day, when you are an established artist, you will have learned the necessity for controlling the reproduction of your works as closely as possible.

This will happen: A woman will buy a painting you did of a church, because she is a member of that church, and she will decide that the church should have prints made of the painting in full color, and that the church should sell the prints and use the profits toward whatever worthy purpose needs to be served at the moment. You may not find out about this until you see a print somewhere. Surprisingly few people think you will be concerned, and surprisingly few printers are aware that it is illegal to reproduce art work, even for the owner of that work, unless he also owns the reproduction rights.

The distinction between owning a painting and owning the reproduction rights to that painting is not widely understood by purchasers of art, or by artists themselves, for that matter. When you sell a painting, you are selling a physical object. The purchaser usually hangs it up and looks at it. He can, if he likes, lend it, sell

it, or give it away. What he cannot do is have duplicates made for any purpose without the express consent of the artist.*

When a painting is sold, the reproduction rights remain the property of the artist unless specifically conveyed to the purchaser in the bill of sale. A lawyer told me that, but on the possibility that he may have been a little wrong, and to make my position perfectly clear, I stamp on the back of every one of my paintings the following:

REPRODUCTION RIGHTS RESERVED
This painting may not be reproduced in any form without the written permission of the artist.

Even so, many difficulties have arisen. One year I got a full-color Christmas card of one of my paintings. The company that sent out the card owned the painting, no doubt about that, and they were shocked and angry when I sent them a bill for $50 for the reproduction rights "for this single use only."

"It's our picture!" shouted the advertising manager. "We can do what we please with it!"

This can be difficult to explain, because the transgressor is almost always completely unaware that he has done anything wrong, and is hurt and indignant at what seems to him a completely unreasonable attitude. What you are doing may seem to him sharp practice—he may think you are using a technicality to send him a bill for something he has already paid for once.

What you have to make clear is that the owner of a work of art can no more publish reproductions of it than he could reprint and sell (or give away) copies of a novel he had bought; and that when a painting is reproduced for any purpose, the artist is due part of the proceeds or other benefit derived from its use. Businessmen usually see this, once it's explained, and any remaining doubt can be dissipated by a short conference with their lawyers.

* Commercial art work, done expressly for reproduction, is another matter. However, if a piece of commercial art work is used a second time, or for a purpose in addition to the original intended use, the commercial artist expects additional payment.

Schools and churches are different. They expect help. "But it's for a Church!" they say, looking at you as if you had horns. "It's for our School!" they say, looking at you as if you had a pointy head. Here is their reasoning, and it sounds quite persuasive. "You made money when you sold us the painting," they say. "All we ask is that you let us do the same thing, without its costing you a penny. You should be flattered to have so many people own your beautiful painting, and every one of them grateful to you for letting us have it done. And we can't believe you'd want to make a profit from a charity drive."

Getting involved in this kind of argument with a group of women is like coming out against mother love and in favor of the man-eating shark. But I have worked out a precarious system. I ask them how much they expect to clear from the sale of the prints. "A thousand dollars, we hope."

"All right," I say, "suppose I were to give you a check for $250, and each of three committee members did the same. You would have $1000, and I'd be saved the problem of having prints for sale in competition with my own paintings and prints."

At this point, I depend on one of the committee to say (and she never fails me) that she can't afford to give $250, as much as she'd like to. This enables me to say that I can't afford to donate $250 either, as much as I'd like to, and can afford even less to donate the entire $1000, which I would be doing if I gave them the right to sell my painting, in print form, for that much profit. This usually creates a dead silence.

Resist the impulse to give your work away, or to give away the right to reproduce it. It can seem flattering when you're asked, and creates a very satisfying feeling of nobility when you give in. But those who ask never realize the size and nature of the gift they are asking for. They think you pick a "masterpiece" at random from the dozens piled up in your studio, like a farmer throwing an apple to a boy from a tree bending down with fruit. Their belief is a part of the folklore that depicts all artists dashing off their work casually and with carefree abandon. You can fight that, but you can't win.

If you are asked to donate to any cause, and you wish to do so, give them cash or a check, so that they (and you) will realize

the exact size and nature of your contribution.

If you should make any agreement with anyone for the reproduction of your work, you should insist on being given the right to approve the accuracy and quality of the reproduction. The agreement should be in writing, should state the amount you are to be paid for the reproduction rights, and the specific number of prints this amount covers, the amount of royalty, if any, to be paid you per print sold, and a firm understanding that the reproduction must meet with your approval before the prints can be published. This is vital; a poor quality, inaccurate print will hurt you more than any amount of income from it can possibly help you.

There are, of course, companies which publish and distribute prints as a business. If your work reaches a level of popularity which makes one of these companies think that your paintings will sell in the form of prints, the company will offer you a royalty arrangement whereby they will pay you a percentage for the works of yours they publish in much the same way that a book publisher works with a writer. This is most desirable, since it is about the only way a painter can develop an income that keeps on coming in when he is not painting pictures.

Once in a while, a painter whose work has gained regional popularity will interest local businessmen or friends in financing a venture into print publishing. Sometimes such a flyer works, but it is more complex than you might think, and more chancy. The subject matter of the paintings must be of broad appeal, because unless a print can be sold all over the country there won't be enough volume to make it profitable. You must succeed in getting a wholesaler who has salesmen on the road calling on print dealers to sell your prints for you. That's the only way you can reach the market. If you publish some prints and the wholesalers are not interested in them, you're stuck. If one of them takes your prints, you're in business, but you're a long way from getting rich. Suppose your print retails for $5. The wholesaler sells it to the print store for $2.50. You sell it to the wholesaler for $1.25, or less, if he can talk you into it, and he might. If you had the print produced by a first-rate lithographer, you may very well have two thousand dollars tied up in plates and printing before you sell the first print. It will take a lot of $1.25 sales before you get even.

If you have confidence, and know some people with confidence *and money*, it might be a worthwhile venture. A firm in Norfolk called Baylor Pictures is composed of two friends of mine with a moderate amount of money and an immoderate amount of confidence. With me as their partner they publish prints of my paintings, and we are making some money, but none of us has any immediate plans for retiring to Florida on the proceeds.

XVIII · The Painter's Rewards

FOR ARTISTS who believe that painting is, or ought to be, a part of everyone's life, the ideas described in this book will work. If these ideas seem simple, it is because the law of supply and demand is basically simple — so obvious, in the selling of paintings, that it has been almost entirely overlooked.

If this method of trying to live by painting seems risky, in that it requires cutting away from any other support, the answer is that life is risky. This method of living from the work you do is less risky than the methods now being followed by thousands of painters — methods which have been thoroughly proved inadequate to provide a living for almost every one of them.

If you feel that your works are worth more than the kind of prices that have been mentioned, you may well be right. You can find out for sure by determining experimentally, as described in Chapter VII, at which price level you can sell them in sufficient quantity to provide you with a living. That is the only way you can tell.

You may disagree with the methods that have been described. But whether you agree or not, a painting is worth, in the economic sense, what someone will pay for it, and if you are to live by painting, you will have to accept that fact. It is novel only in the field

130

of art. In every other field, it is accepted as a matter of course.

There have been many theories advanced as to why, in the world's most prosperous country, during one of its most prosperous periods, artists have found so small an audience.

It has been said that "art is by the few, and for the few," an idea advanced, significantly enough, by the "few" who keep repeating it. From the tone of their voices, they like it that way.

It has been said that the age is too materialistic, too worshipful of the "bitch goddess, success," to find time for the creative arts. It has been said that painting has become decadent, introverted, and meaningless. The arguments rage — among critics, among artists, among museum directors, among dealers.

This book suggests a simple thing. Let's take paintings to everybody. Let's say to everyone, "Here is a picture. It is priced so that you can afford it. Hang it up where you can see it. If, with time, you find that it means more and more to you, you will want another one, and you will be able to afford it, too. If, as time passes, you become interested in painting because of these pictures, your taste will improve as you study the work of artists. Someday you will need painting as you need music, and books — as you need peace and love. You will be better off because of this — and happier."

When I expound this thesis — and I can get pretty worked up over it — someone says, more often than not, "Come down to earth, man. You're a wild-eyed idealist." I would rather be. If you're going to be wrong, that's the direction to be wrong in. I would rather believe in people and be wrong than not believe in them — and be wrong. But it is rather strange to be accused on the one hand of being mercenary and "commercial" because one sells paintings at low prices, and then be accused of being a "wild-eyed idealist" by the same critics, because one believes that art ought to be for everybody.

One of the things that has been said about these ideas is that such a plan is all right for a painter of limited ability, but that it has no usefulness for a really talented man. This is asinine on the face of it. If it will enable a painter of small talent to get his work before people, it will enable one of great talent to do the same thing ten times better. And if paintings are not for people (I want

to ask the question again), what are they for?

Being a painter is a great privilege and, like most privileges, it has to be worked for if you are to deserve it. Most of the young people who start out to be artists don't make it. Some of those whose talent seems to offer the most glowing future, burst like a rocket and then fade out. And some of the plodders, who climb slowly and painfully, end like the plodder Cézanne, at the top of the long hill of success.

Painting is not simply a matter of talent. It is a rare mixture of sensitivity and fortitude — sensitivity to the earth and to the pageant of man's life upon it; and fortitude to wrestle with the images that come, and to try again and again, amid failure, to give these images form and meaning. It is a lonely life, because what you do, you do alone — and if you succeed now and then, you do not know it.

But it is a privilege to try. And there is a satisfaction in painting for people as a whole that can never be got from painting for the limited audience of the salons. I remember the postman in Raleigh who had been delivering mail to the Art Gallery for thirteen years without ever seeing a painting he could afford to buy or having anyone suspect he wanted one. He brought his wife and four children to my show. After an hour of study and whispered consultation they decided on *The Coming of Spring* for $35. It was not that the painting had previously hung in the Southeastern Annual that decided them, because they did not know that. It was because, in the words of his wife, they felt it was "lonely and warm, like April." A painter could not ask for more perceptive understanding.

I remember the soldier who walked up the steep canyon road to my home in Manitou Springs, Colorado, in 1944 with $10 he had scraped together from a private's pay. He bought the sketch of a gnarled oak branch and asked me to mail it to his wife in Washington, D. C., then sat on the steps and described the apartment to me; where the sofa was, and the design of the mantel over which he figured she would put the picture. "I can just see it," he said. His division was shipping out for overseas and the painting was a sort of going-away present. I keep hoping he got back all right and that everything was the way he had imagined it would be.

By putting your pictures within the reach of everyone, you do more than make a living. You gain a feeling that you are a part of a world that needs what you have to offer it.

As to the lasting worth of your work, you will never know the answer to that in any case. But its merit will not be less, I believe, because you shared the ability you had with as many people as possible.

Appendix

We are indebted to Mr. Lincoln Rothschild, former executive director of Artist's Equity Association, for the preparation of the following paragraphs, and for the Association's permission to publish them here, along with the AEA forms which follow.

ARTISTS EQUITY ASSOCIATION ON ARTIST-DEALER RELATIONS

Many artists feel an emotional need to exhibit their work, beyond the realistic opportunities for financial profit; and others feel that payment for a one-man show that has no apparent justification in an immediate increase in sales is nevertheless a valid investment in their "reputations" that will be returned in the future.

In either case there is no clear objective indication as to what the show is "worth" to the artist, and he often has the unpleasant sensation, true or false, of being squeezed like a lemon by fast-talking commercial characters, or by people who have to face the economic realities of paying the rent and such.

A considerable number of artists have arrangements with dealers in which they are constantly represented, have one-man shows every two or three years, and pay nothing but a commission on sales. In fact this was the traditional arrangement until comparatively recent years, based on standard marketing practices. The merchant generally buys his goods at wholesale, but in the case of highly priced units, arrangements are sometimes made where the manufacturer lets him have stock on consignment, to be paid for after it is sold, or returnable if unsold. Only in the sale of a work of art does the producer *pay* someone to *try to sell* his work.

In an attempt to prevent excessive exploitation of the artists' need to exhibit, to "hold the line" on releasing dealers in art from making any investment in living artists (the less the investment, the less the need for them to make any efforts to sell), and to facilitate some sort of concrete agreement that should form the basis of any commercial relationship, Artists Equity Association undertook to prepare a form of contract for guidance in relations between artist and dealer.

The instructions which follow the contract indicate clearly the manner in which the document is intended to function. It should be used flexibly, to suit the particular situation. A list of conditions that are generally considered desirable, and should be the eventual objective of the exhibiting artist, is presented under "Generally Accepted Practices Among Gallery Artists," but the opportunities to get them are limited. Transactions of artists with dealers should also be clarified by the use of receipt forms and bills of sale which reserve reproduction rights, as presented herewith.

ARTISTS EQUITY ASSOCIATION

AEA—ARTIST–DEALER FORM OF CONTRACT

1. The Gallery (address) (City), referred to hereafter as "the Gallery," agrees to act as sales representative for referred to hereafter as "the Artist" for a period of year(s) from date.

2. This contract may be cancelled by either party on written notice after days, (or) after the end of the exhibition season in which the contract is cancelled, to be considered as date.

COMMISSION

°3. The Gallery shall receive percent of all sales made on its premises.

°4. The Gallery shall receive percent of any portrait, sculpture or mural commissions it gets for the Artist and percent of any others awarded during the period of the contract.

°5. Commissions on purchase prizes shall be calculated at percent of the regular gallery list price.

°6. The Gallery shall receive percent of any sales made by the artist personally, without the assistance of the Gallery, provided, however, that no commission shall be paid on any sales referred to in this paragraph, unless the dealer makes sales in the contract year of at least $................ for the artist.

°7. The Gallery shall not receive any commission on royalties, sale of reproduction rights or commercial assignments unless arranged by the Gallery, in which case the commission will be percent. The Gallery shall receive percent on works of fine art which it sells for commercial use. It shall be understood that all sales are made exclusive of reproduction rights, and written acknowledgement of that fact shall be obtained from purchaser by Gallery. Reproduction rights may be specifically purchased with the Artist's written consent in each case.

8. Materials, installation and foundry costs on sculpture and murals shall be deducted before calculating commissions.

JURISDICTION

9. During the period of the contract the Artist shall not contract for any other representation except in the following fields:

................................ local representation outside of the city in which Gallery is located

................................ foreign countries

................................ other (i.e., print galleries)

The Gallery may arrange for representation of the Artist by another agency in any field reserved to it by this contract, but must arrange to pay such agency by splitting its own commission, with no added charge to the Artist.

10. In addition to continuous sales representation during the term of this agreement, work of the Artist will be exhibited in the Gallery:

................................ in a one-man show of weeks duration at least once every years. Said show shall not be at the same time as any other one-man show in the Gallery.

................................ at least one work will appear in a permanent exhibition of the Gallery Group.

................................ at least one work will be exhibited in all gallery group shows, of which there will be at least every year.

11. Storage space will be provided at the Gallery for at least works.

*12. The Artist will receive the following opportunities to cooperate in formulating the policy of the Gallery: ...

...

EXPENSES

*13. When the Artist has a one-man show at the Gallery, all related costs will be borne by the Gallery.

14. The Gallery will meet expenses of packing and shipping work sent to clients and exhibitions.

*15. The Gallery will insure all work in its possession against loss and damage up to% of sale price.

FINANCES

*16. The Artist and the Gallery will agree in writing on prices for all work in the possession of the Gallery. The Gallery may not accept a lower offer without the Artist's consent in writing.

17. All works are received by the Gallery in trust. All sums received by the Gallery on account of works sold are received in trust and the net proceeds, after deduction of commission and expenses agreed, to be chargeable to the Artist, shall be immediately deposited in a special trust bank account and there retained until paid out to the Artist.

18a. The Gallery will pay the Artist on or before the 15th of each month, the amount due him from any sale, made in the previous month, regardless of any arrangement the Gallery may make with the client for deferred payment or financing of the sale. The Artist's consent to participate in any arrangement for deferred payment to him must in each case be obtained in writing.

Or

18b. The Gallery will pay the Artist $................ per month for the period of the contract, which shall be minimum compensation. The Artist will receive a quarterly statement of his account, and will be paid any excess of Artist's share of sales over his monthly allowance at the end of each year of the contract.

*19. The Gallery will set up a welfare fund consisting of% on each sale contributed by the Artist and% by the Gallery.

20. A Standard Artists Equity receipt will be given the Artist for all work received and he must acknowledge in writing all work returned.

21. Annual statements in writing covering sales, receipts, payments to the Artist and all other matters, together with a list of work on hand, will be furnished by the Gallery within thirty (30) days after the end of each year of the term hereof. The Gallery shall keep adequate records of all its transactions with respect to each Artist's work, which records shall be available for inspection during the regular business hours by the Artist or his representative authorized in writing.

22. Further arrangements:

...

Date

...

For the Gallery

...

For the Artist

...

Witness

*See instruction sheet

AEA—ARTIST–DEALER FORM OF CONTRACT—INSTRUCTIONS

A good dealer is obviously the most important adjunct an artist can have in building his career. However, many artists who are not quite ready to exhibit or somehow failed to make a connection, are apt to pay excessively for a one-man show with which they get little else, or may spoil a potentially good relationship by neglecting to clarify mutual responsibilities in advance.

On the business side of an artist's career, as in any business, nothing should be left to a vague understanding that the dealer is a gentleman and will "do the right thing." Not that dealers are dishonest or unfair, but there often is no "right thing." What's "right" for an artist's first one-man show is quite different from what he can expect after a successful series, but even then differences may arise. The trouble with any assumption is its one-sidedness. A written contract serves as mutual notification between the contracting parties that all assumptions are accepted—i.e., they are no longer merely assumptions.

The preceding form is drawn with items and blanks intended to anticipate many possible contingencies and variations, from a first one-man show to an exclusive agreement over a number of years. Any points that do not apply can be crossed out or the blanks filled in with a negative indication. Of course, it should be executed in duplicate, one copy to be held by the artist and the other by the dealer. Following are specific suggestions on points that may not be apparent from the wording of the contract:

3. One-third is the usual commission.

4–7, inclusive—are based on (1) the consideration that any promotion done by the gallery over a considerable period builds the reputation of the artist; and (2) that selling by the artist is competitive and reduces the gallery's potential market.

6. Amount of commission, if any, payable by the artist to the dealer on his own sales, should depend on (a) amount of sales made by dealer; (b) promotion given by dealer; and (c) services furnished by dealer without cost to the artist. Customarily commission is not paid on charitable sales unless the artist receives the full gallery price.

7. "Written acknowledgment" is contained on Equity standard bill of sale.

12. A few galleries consider their regular artists as a group with common interests and encourage them to function as such. They might have one or two meetings a year, with a small representative committee elected to meet more frequently and deal directly with the gallery management.

13. Although Artists Equity, in principle, is against the practice of demanding payment by the artists for any of the costs of exhibiting in a commercial gallery, there are many factors which may make it seem acceptable to individual artists. There is no fixed rule about charging for an exhibition except that the dealer (in any commodity) invests his money according to his chances of sale.

If a dealer offers you a show for which you must pay and you are willing to do so, first negotiate as low a figure as you can, and make sure you know (1) how much you are to pay in exact figures; (2) what you are getting for it; and (3) is it worth it to you? Don't count on reducing the charge by selling unless you have concrete reasons for being certain you will. It comes down to this. If the dealer thinks you have a chance to sell, he should back his judgment to some extent. If he doesn't, you're gambling, or investing in

the future. Should you decide to do so, substitute something like the following, according to the conditions agreed upon.

13. When the Artist has a one-man show at the Gallery, he will pay the following expenses:

$................ for rental of Gallery, including attendants, lighting and costs of hanging.

$................ for an opening reception.

$................ newspaper and magazine advertising to be placed by the Gallery.

$................ cost of printing and mailing announcements and catalog.

$................ photographs for the press.

$................ other promotion or publicity.

The Artist agrees to pay a deposit of $................ against these charges on signing an agreement for the dates of the show, and the balance within days thereafter. Should commissions on sales from the show amount to less than the balance of the expenses, the Gallery agrees to take picture(s) at the sale price less commission, on account.

15. Important. The best attendants drop things when under pressure, but the general public and outside tradesmen can be quite clumsy.

16. Standard AEA Receipt carries information on prices.

19. Uncommon. Might total about two or three percent of sales.

Some guidance in arriving at figures and conditions can be gained from the accompanying list of "Generally Accepted Practices among Gallery Artists." This represents the usual demands of artists well enough recognized to stand in a favorable bargaining position with their dealers, and may be modified to some extent for others.

GENERALLY ACCEPTED PRACTICES AMONG GALLERY ARTISTS

1. The Gallery is the sole agent for its members, and every member artist has the right to enter into a contract which shall be of at least one year's duration.
2. Exceptions to the foregoing clause are that commercial art and prints may be handled by agencies or galleries dealing exclusively in commercial art or prints.
3. Each member artist is entitled to a one-man show of three weeks duration at least once every three years, without payment.
4. Each member artist is also entitled to participate in all gallery group shows, at least one of which is held every year.
5. The Gallery provides storage space for representative works of each of its members.
6. The artist and the dealer agree on the price of each work of art when it is delivered.
7. Artists should require that they be reimbursed the 15th of the month following payment to the Gallery, and also that information as to who bought the work be made available to the artist.
8. The artist receives a receipt for each painting delivered to the Gallery, and at the end of the year should require an inventory statement of his works at the Gallery.
9. For all works sold at the Gallery, the dealer receives 33⅓%.
10. In the case of sculpture, where there is a foundry cost, and in murals, where there are excessive material costs, installation, etc., these deductions shall be considered before commissions are determined.
11. In the case of a split commission, the Artist shall retain his full percentage, 66⅔%.
12. Prizes are not subject to commissions, except purchase prizes, in which case the gallery shall receive ⅓ of the regular gallery selling price.
13. Full membership meetings of the Gallery Artists should be held at least once a year, together with the dealer.

Artist's Equity Association—Standard Receipt Form

Received from ...
Name of Artist

Address .. Phone

the following:

			Selling Price	% Commission
Title	Medium	Size		
1.				
2.				
3.				
4.				
5.				

(Use additional sheets if necessary.)

for ...
purpose: e.g., sale, exhibition, inspection, etc.

to be held from .. to
date date

Until the works listed above are returned to the possession of the Artist, each will be fully insured against loss or damage for the benefit of the Artist in an amount not less than the selling price less commission. None may be consigned, sent out on approval or removed during the period of the exhibition except as agreed in writing. All of the above works are to be returned to the Artist on demand. Reproduction rights reserved by artist.

...
Signature of Dealer or Agent of Gallery

..
Date

Consent is hereby given to send work out on approval.

.. ...
Date Signature of Artist

Standard Artists Equity Association Bill of Sale

Place Date

(Fill out in duplicate)

Sold to (Name) ...
(Address) ...
...

Description of work: Price:

Terms of payment:

Reproduction rights reserved

(Signed)
Purchaser Artist or Authorized Dealer

Index